THE FINE

ARTS

SERIES

THEORY AND PRACTICE

BASIC PRINCIPLES
& LANGUAGE OF FINE ART

The Fine Arts Series was originated by
Pieter van Delft and Bert Willem van der Hout,
Alpha Design, Amsterdam.

Research and text
Tine Cortel and Theo Stevens

Editor: Carla van Splunteren

Design: Bert Willem van der Hout,
Alpha Design, Amsterdam
Layout: Louk Leffelaar

Cover Photo: Pieter Paul Koster
With thanks to: Henricus Rol
Translation by: Tony Burrett
and Carla van Splunteren

Typesetting: Euroset BV, Amsterdam

Lithography: Nefli BV, Haarlem

Printing: Royal Smeets Offset BV
Weert, The Netherlands

Illustrations:

Fred ten Brave, Amsterdam:
page 101.

Martin Smit, Apeldoorn:
pages 76, 77, 78 left, 79.

Koninklijke Smeets Offset BV, Weert:
pages 9, 14 below, 15 below, 16, 17, 18, 19,
27, 28, 29, 64, 65 below, 66, 73, 74, 75, 78
right, 80 above, 86, 87, 88, 89, 91 below, 92
above, 93 below, 95, 96 below, 97, 111, 116.

Theo Stevens, Amsterdam:
pages 10, 11, 12, 14 above, 15, 20, 21, 23, 24,
25, 26, 30, 31, 32, 33, 34, 35, 36, 37, 38, 39,
40, 41, 44, 45, 46, 47, 48, 49, 50, 51, 52, 53,
54, 55, 56, 57, 58, 60, 61, 62, 63, 65 above,
67, 68, 72, 80 below, 81, 82, 83, 84, 85, 90,
91 above, 92 below, 93 above, 94, 96 above,
98, 99, 100, 102, 103, 104, 105, 106, 107,
108, 109, 110, 112, 113, 114, 115.

Koninklijke Talens BV, Apeldoorn:
pages 41, 42, 43, 69, 70, 71.

With thanks to (for advice and materials):
Koninklijke Talens BV, Apeldoorn.
Papierfabriek Schut, Heelsum

Part 2.

British Library Cataloguing in Publication Data
Basic principles and language of fine arts. –
(The Fine art series)
1. Paintings. Techniques
I. Series
751.4

ISBN 0-7153-9475-4

© 1987 Royal Smeets Offset b.v.
ADM Books, Amsterdam.
Alpha Design, Utrecht.

English edition © 1989 by
David & Charles plc, Newton, Abbot, Devon

First published in Great Britain 1989 by
David & Charles plc, Newton, Abbot, Devon

THE FINE

ARTS

S E R I E S

THEORY AND PRACTICE

BASIC PRINCIPLES
& LANGUAGE OF FINE ART

DAVID & CHARLES
Newton Abbot · London

CONTENTS

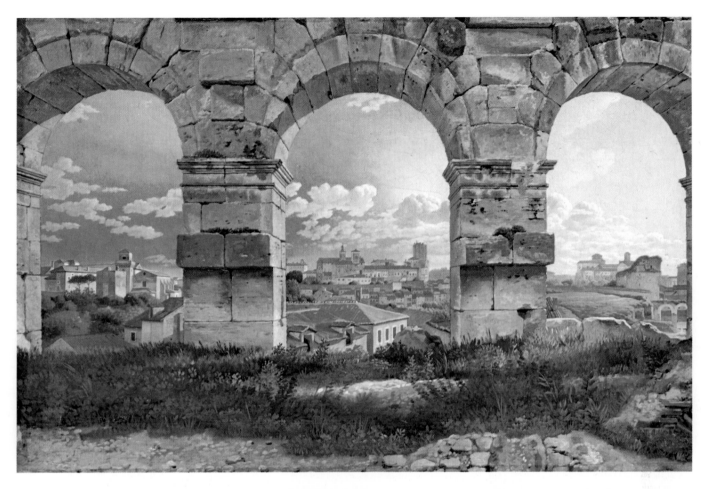

When the artist painted this view of Rome, he was standing directly in front of the centre arch. Notice the different ways in which the thickness of the walls is indicated. Both the front and rear curved lines of the arch are completely visible. In the left-hand arch, the rear curved line disappears out of sight to the right; from the right this disappears to the left-hand side of the arch. The direction of the stones emphasizes the centrally-positioned vanishing points.

View of Rome From the Arches of the Colosseum – 1813-16
CHRISTOFFER WILHELM ECKERSBERG

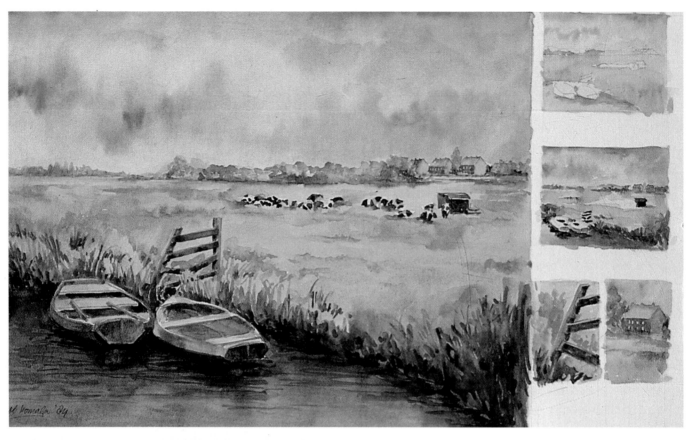

The Pyromaniac
– undated
WILLEM WAGENAAR

The composition of this painting is determined by the planes of the walls of the room, the window and the brick wall, which are drawn in perspective. The scene takes place between dream and reality, and the artist emphasizes this not only by shape, but also by the strong contrast in colour.

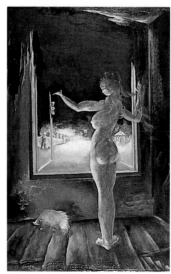

Meadow Landscape
– undated
ROB KOMALA

With the aid of only a few effects of perspective the viewer can see far across the landscape. The effect of depth is heightened because the colours and shapes in the foreground are emphasized and fade towards the horizon. Komala painted his landscape on the same piece of paper on which he had made his preliminary studies, and in so doing added extra composition to his work.

INTRODUCTION

Every artist approaches his chosen subject in his own way and depicts it in his own way. This personal approach is essential to the creative and expressive value of the work. You may wish to give priority to depicting the subject as accurately as possible; on the other hand you may choose a method of working in which the purely visual image is much less important than the thoughts and emotions the subject arouses in you. The right choice of material is an important factor in translating the subject into line, colour or plane and here, too, personal preference is of the utmost importance. One person will feel attracted by plane and colour, another will choose line.

Whichever method of working you choose for the depiction of your subject, you are always confronted with those elements from which a drawing or painting is constructed: line, shape and colour, and, following from these, tone, structure, movement, perspective and composition.

Composition determines the manner in which you divide your working surface and a good division of the surface promotes a harmonious balance in your work.

If you wish to introduce depth into your work you can do so by creating a certain perspective using colours which either dominate or tend to recede into the background, but you can also apply the principle of linear perspective, through which the object or objects in your work will be in a particular proportion to each other.

The use of linear perspective also enables you to indicate from which angle the piece of work was established.

When depth is created on a two-dimensional working surface – whether by means of colour or linear perspective – the work acquires a third dimension.

The intention of this book is to familiarize you step by step with the theory of colour, composition and linear perspective and to clarify these important subjects as far as possible. These theoretical discussions will serve as a guideline to enable you to solve the problems you will meet in your work; it is not intended that you follow them implicitly.

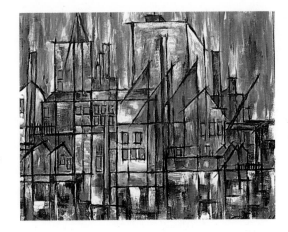

City
– undated
WILL GORIS

Goris painted this view of the city in planes of colour over which he drew black lines. The changing planes of colour and the constantly repeated straight and diagonal lines suggest a jumble of houses, large and small, all huddled together. The effect of depth in the painting is largly created by the use of planes of colour. Only in the huge grey building, which stands out high above the city, is a receding perpectival line visible. This line pushes the building into the background.

PICTORIAL ELEMENTS

As we mentioned earlier, drawings and paintings are constructed from certain elements – *line, shape* and *colour* – which, when they are applied, create *tone, structure, movement, perspective* and *composition*.

Which of these elements are present in a piece of work depends on the choice of materials and the way in which these materials are used. These various elements are explained in the examples below.

I

II

III

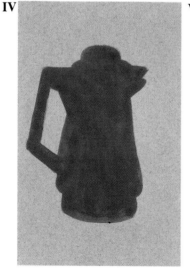

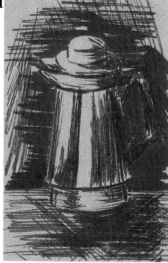

IV

V

VI

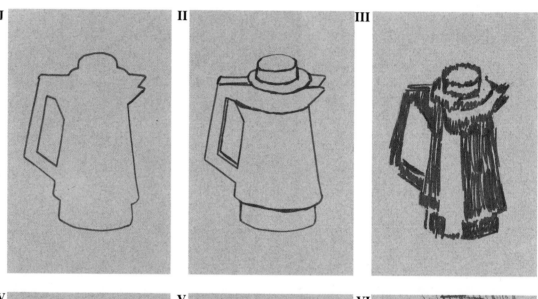

I An object can be depicted using a medium which gives a line – such as a pen or a pencil. If you wish, you can limit yourself to the essence of the shape which you set down in line. You have therefore applied two elements – *line* and *shape* – in the drawing of the jug.

II You can also introduce further details into the line drawing so that the jug becomes three-dimensional. The drawing now contains three elements: *line, shape* and *volume* (*perspective*).

III Structure is created by introducing areas of shadow into the drawing. The line structures give the drawing tone and create a greater effect of depth. The drawing now shows: *line, shape, structure, tone* and *perspective*.

IV The jug can also be drawn as a plane. The drawing now contains only *shape* and *plane*. Your *composition* determines where you place the jug – the object has a particular relationship to the working surface. Imagine that you have drawn the jug, not in black, but in coloured pencil or pastel. *Colour* would then have been added to the elements of *shape and plane*.
The form in illustrations I to IV is said to be *positive*.

V A *negative* form is created when the background, rather than the subject, is drawn or painted, and the subject itself is left blank. Thus, in this drawing the jug is blank paper. This method of working is often used in watercolour painting. By leaving it blank, the light is in the subject and then areas of shadow are applied. Like that shown in illustration IV, this drawing has *shape, plane* and *composition*.

VI The jug is placed on a horizontal surface and a structural background added. These structures are laid down in a particular direction, to some extent following the lines of the jug. This creates movement. This drawing therefore has: *line, plane, shape, structure, movement, perspective* and *composition*.

These illustrations show that every piece of work contains one or more pictorial elements. If you are going to make a painting or a drawing, you must first decide which elements you wish to employ – line, shape colour, or a combination of these. Your choice of materials obviously depends on this decision.

If you choose line, for example, you will use a material with properties suited to this purpose: pencil, pen and ink, chalk or charcoal. Chalk and charcoal, like ink, can be used to give tone to your work. With chalk and charcoal, tone is achieved by brushing and rubbing; with ink by using a paint brush.

When making a pen drawing, you look at your subject with very different eyes than when using paint as a medium. In the first case, you concentrate on line, in the second on colour and plane. No matter which material you are planning to use, you must always first examine the subject carefully. You will discover that the subject is built up from various basic shapes. After a little investigation you will also find that the subject often contains geometric shapes and lines. It is recommended that these basic shapes and lines are sketched first so that you can more easily determine the form and proportions of the subject. You make a plan in advance, therefore, in order to simplify your design.

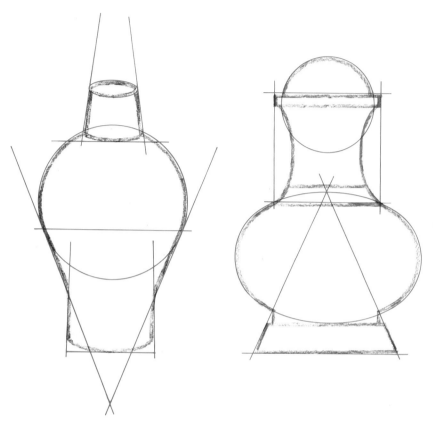

In these sketches it can be seen that both of the Chinese vase forms contain circular, elliptical, conic and right-angled shapes, while the tea chest is enclosed between diagonal lines and a right angle. Thus Breughel's painting principally contains diagonal lines, and Vermeer's mainly straight lines.

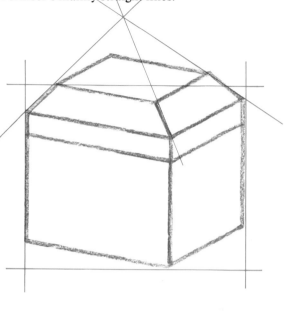

The Street – c. 1661
JAN VERMEER

Hunters in the Snow –
1565
PIETER BREUGHEL
THE ELDER

I Drawing materials can be handled in different ways, and lines, therefore, can be drawn differently: rigid and sharp, thick and thin, and soft and faint. This is known as the 'character' of the line.

Of course, you can sometimes use a ruler to draw a line, but this must remain the exception rather than the rule: a drawing built up of ruled lines is stiff, cold and without feeling. It can be seen in these examples that a line drawn freehand has more character and feeling. Use a ruler only to determine planes of perspective.

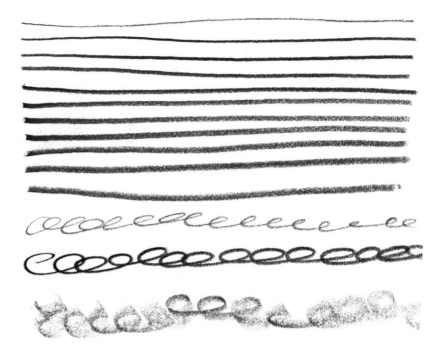

II All kinds of structures, which can be worked with straight or curved lines, can be made by repeating lines and constantly changing their direction. Lines can also be applied with paint brushes.

Paloma – 1953
PABLO PICASSO

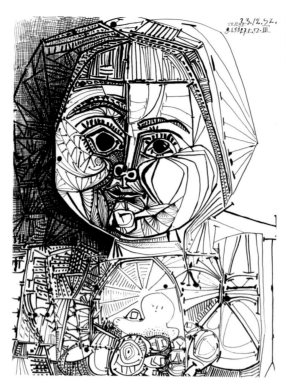

III Picasso used all kinds of line structures in this pen drawing. When he applied the areas of shadow, tone was created by these structures. He first laid down an extremely fine line structure, and then drew the lines of his subject over it.

Narcissi – 1561
WANG KOU-HSIANG

IV The Chinese and Japanese have always been masters in the handling of pen and brush, which they control in such a way that there is often no discernible difference between the stroke of a reed pen and a brush-stroke. They are even able to draw gossamer-fine lines with a brush. We have them to thank for a wealth of works of art in this medium.

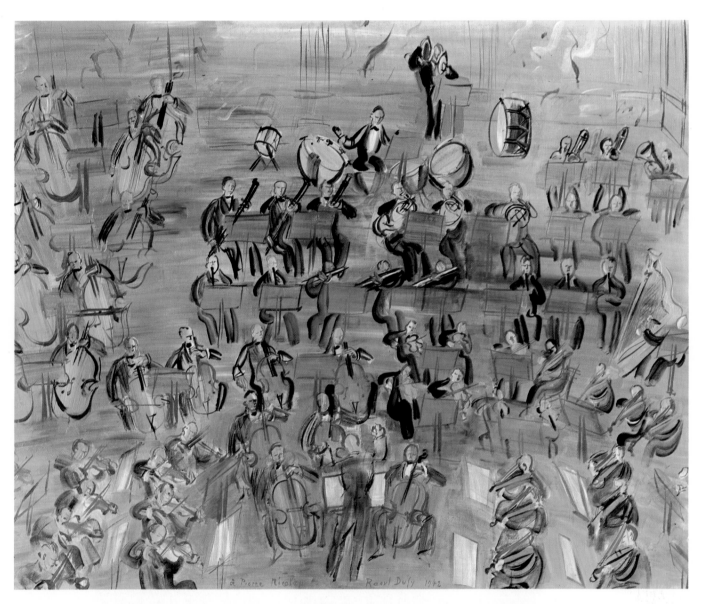

V Dufy frequently employed line structures in his paintings. All the lines were applied with a brush. The work is painted on a pre-coloured surface. In this painting, line plays the most important role and colour is of secondary importance. Practically everywhere colour is employed to give accents, and not to create a recognizable image. The great effect of depth which characterizes the painting is due to the fact that the stringed instruments in the foreground are seen from above, while those in the middle of the canvas are seen from directly in front. The repetition of the instruments creates a rhythmical effect.

The Large Orchestra – 1942
RAOUL DUFY

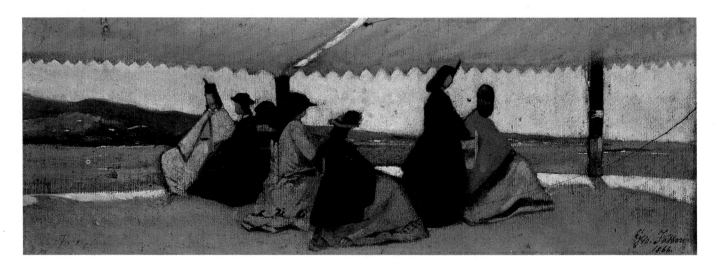

*The Roundabout in
Palmieri* – 1866
GIOVANNI FATTORI

VI In this pastel drawing by Fattori, colour and plane predominate. Pastels can be used to depict both these elements equally well. The horizontal lines accentuate the long, narrow format of the paper and bring balance to the composition.

Movement is a pictorial element which can be seen in almost every piece of work. Sometimes this is immediately recognizable, but sometimes it is rather more difficult to discern. Movement can be created by the effect of brush or line, but it can also be created by repetition of shape or colour stroke.

VII In this painting, Victor Hugo clearly gives his vision of life: 'The wave is lifted up from the depths but returns irrevocably to its source'. The water, at first so peaceful, appears to flow faster. It is then driven upwards, breaks at the point from where it originated and again becomes part of that same wave.

Trapped in a vicious circle; imprisoned within the limitations of the canvas. Symbolic of the inescapable limitations of life. In this work, colour and line play an equally important role.

My Fate – 1866
VICTOR HUGO

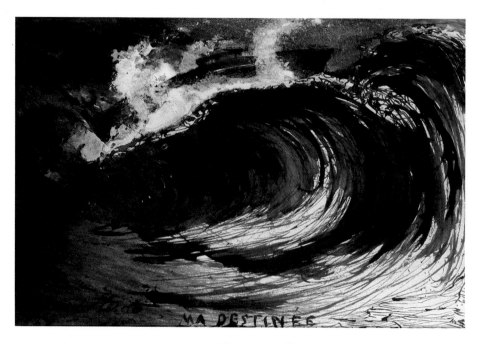

THE FINE ARTS SERIES

The Scream – 1893
EDVARD MUNCH

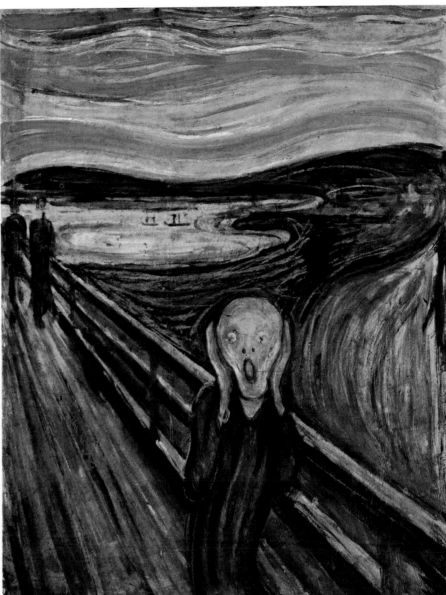

VIII While Victor Hugo's painting symbolizes limitation, *The Scream*, by Edvard Munch, is an example of the transgression of fixed boundaries, of breaking through the limitations imposed by the canvas. The scream continues into the sky, into the water and the land, and into the figure in the foreground. Munch wandered along a fjord at sunset. He felt ill. The sky became red and he heard a scream bursting through nature: 'The colours were shrieking'. He pressed his hands over his ears to keep out the scream. Notice the stark contrast between the terrified figure in the foreground and the solemn, restful strollers in the distance. They have obviously heard nothing. Rarely has such desperate, despairing fear been so effectively captured in a painting.

An Expressionist painting which is pure movement.

IX This painting by Balla also contains much movement. The movement is accentuated by the repetition of image and technique. The girl is seen in the different phases of the movement almost as frames of a film racing before our eyes. The composition has a clear vertical, repetitive line.

Girl Running Along the Balcony – 1912
GIACOMO BALLA

COLOUR

THE CREATION OF COLOUR

Colours owe their existence to light, because, generally speaking, they are not recognizable in its absence. The sun is our principal source of light for distinguishing colours. Exceptions to this are the colours of incandescent metals, (the colour of the light from an electric light bulb, for example), or those of the flames of burning gas, wood or oil, or the colour

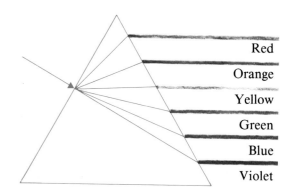

A beam of light passing through a prism is refracted, making the colours of the spectrum visible. By using two prisms, the beam of light is separated and recombined.

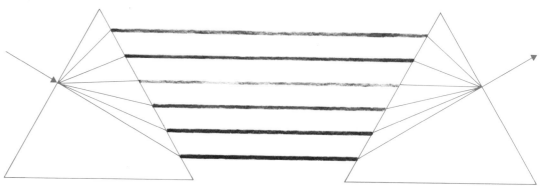

The colours from which daylight is composed become visible in a rainbow.

of a fluorescent metal tube – all of which are visible in the dark.

Although we regard daylight as colourless-white, it consists basically of a series of colours. If light is refracted and the colours thus separated, we are able to distinguish them. A rainbow is an example of this phenomenon. A rainbow is created when sunlight falls through small drops of rain at a certain angle: the drops act as prisms. The rays of light are refracted because they are, as it were, 'slowed down' as the light passes through a more solid substance.

Rays of light passing through a prism are refracted twice – once as they enter and once as they leave. Because the colours in sunlight have different angles of refraction, they become visibly separate.

Of these colours, red has the largest angle of refraction and violet the smallest. In this way the visible colours of the spectrum – red, orange, yellow, green, blue and violet – together with the colour nuances which lie between – reddish-orange, orange-red, orange-yellow, yellowish-orange, yellowish green, greenish yellow, greenish blue (peacock blue), bluish green, bluish-violet and violet-blue – are created. These refracted colours can be combined back into white light by means of a second prism, which neutralizes the refraction.

ADDITIVE MIXING Red, yellow and blue are primary colours. When we project two primary colours so that they fall one over the other, a secondary spectral colour is created. For example, red and yellow beams of light produce orange, red and blue produce violet, and yellow and blue produce green. If we project the three primary beams of light one over the other, white, colourless light is created. This white light again contains the three primary colours of red, yellow and blue, but in addition it also contains the secondary colours of orange, green and violet. Mixing of coloured (intangible) beams of light is known as *additive mixing*.

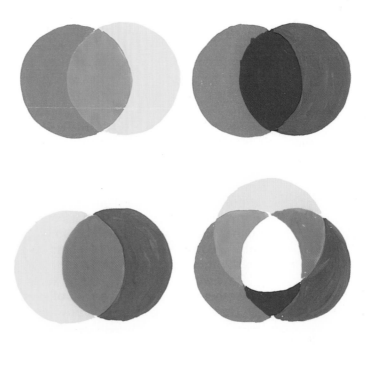

SUBTRACTIVE MIXING Besides mixing coloured (intangible) beams of light, we can also mix coloured (tangible) materials such as chalk and paint. Mixing coloured materials is known as *subtractive mixing*. As is the case in additive mixing, mixing materials of two primary colours creates a secondary colour. If, for example, we mix red and yellow paint, orange is produced. Red and blue paint mixed produce violet, and yellow and blue mixed produce green. If three primary gouache colours are mixed together, however, a dull, grey colour, and not white, is created.

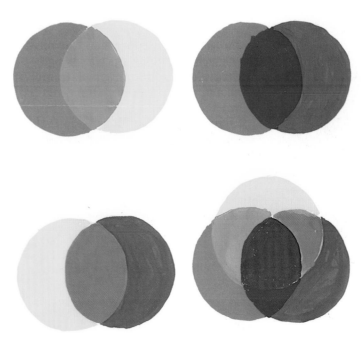

RADIATION Besides the visible colours of the spectrum, there are a large number of electromagnetic radiations which we are not able to see. Next to visible spectral red, for example, lies infra-red light, which we cannot see, and next to visible spectral violet lies invisible ultra-violet light.

Invisible light:
Radio and television
Radar
Microwaves
Infra-red light

Visible light

Invisible light:
Ultra-violet light
X-rays
Gamma rays

In the diagram, a few other forms of radiation are indicated. Some of these do not penetrate through to the surface of the earth but are absorbed by the atmosphere. Others, which do penetrate the atmosphere, are used advantageously. For example, radio waves are used for sound, ultra-violet rays for sunlamps, infra-red rays for radiotherapy and X-rays for radiography.

Rays which are emitted by the sun and other stars consist of pulses of energy. Each pulse can be broken down into:
– frequency (the number of pulses [or *cycles*] per second)
– period (the duration of a cycle)
– wavelength (the distance one cycle covers in one period).

As far as colour is concerned, the most characteristic property is wavelength. The wavelengths of light are extremely small and are expressed in nanometers (n.m.).
 1 nanometer = 1 billionth of a metre.
 Visible spectral light lies between 390 n.m. and 790 n.m.. Colours in the shortwave region:

violet	390 – 436 n.m.
blue	436 – 495 n.m.

Colours in the middlewave region:

green	495 – 566 n.m.
yellow	566 – 589 n.m.

Colours in the longwave region:

orange	589 – 626 n.m.
red	626 – 760 n.m.

Spectral longwave red is the least refracted colour and shortwave violet is the most refracted, which is why these two colours lie the furthest apart in the spectrum.

COLOUR AND MATTER Matter (from which all objects consist) owes its specific colour to the light which falls on it. Certain wavelengths are absorbed and others reflected. It is the reflected wavelengths which determine the colours that we see.

 For example: if we see a red object, then that red is the reflected spectral colour – the other colours have been more or less absorbed. If we see a violet colour, then it is the shortwave violet rays which are reflected and the others which are absorbed.

 When *all* the light rays which fall on an object are reflected, we see that object as white. Then we speak of *total reflection*. (When light rays are reflected their heat is also reflected, which is why summer and tropical clothing, ice cream vans and tankers are often white.)

 When all the light which falls on an object is absorbed, we see that object as black. (The heat is also absorbed, which is why we feel warmer when we wear black clothes than we do when we wear white.)

 If a surface is completely smooth (for example, a layer of ice or a varnished surface), the light is reflected more or less in one direction and a *mirror reflection* is created.

 If the surface is not completely smooth (for example, fresh snow or rough white fabric), then the light is reflected in all directions. This is known as *diffused reflection*.

The boat is veiled by the greyish violet morning light.
No shadows are visible in the early morning.

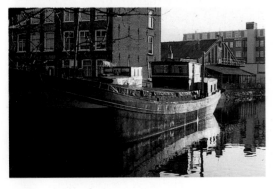

The boat lies in the sunlight; the colours are brighter.
Sunlight creates shadows, which gives objects more contrast.

THE DIFFERENT INFLUENCES OF DAYLIGHT

In general we begin with the premise that daylight gives the best impression of a colour and that artifical light has an influence on the original colour. (We only need to remember that when we wish to buy clothes or a piece of material, we go outside the shop in order to examine the colour.) Nevertheless, daylight is also susceptible to changes in colour. The composition of light varies from morning to evening, from summer to winter, from north to south and from east to west. The degree of latitude also influences the colour of daylight. The light in northern Europe, where the sun is at a comparatively low altitude, is much weaker than the light around the equator, where the sun is at its highest. The early light gives a landscape almost insubstantial grey colours. At daybreak shadows are barely visible. As it becomes lighter, this grey changes to grey-violet.

Because light in the long wavelength region is the first to reach the earth, the sky can turn red-orange, as a result of which our surroundings appear much warmer. If the sun is visible, the shadows become sharper and under the influence of the red morning sky they take on a violet colour. Morning light, however, can also be pale yellow; on a cloudy day the light will remain white-grey for quite a while. As the sun rises higher in the sky the light increases. The colours become brighter and the shadows shorter and less clearly defined. Sunlit clouds appear white. Thick, black clouds do not allow sunlight to pass through them and appear grey, often with white edges.

Daylight consists of direct sunlight together with the light which is reflected from the sky. Daylight is clearest and colours at their most natural around noon. When the sun has passed its zenith, the light declines because the blue is filtered out. The red and orange light begin to dominate, because of this. Later in the day, they will gradually fade and shadows again become longer and bluer.

As the sun sinks lower, contours become sharper. The late afternoon sun gives the landscape an orange-yellow colour, still later in the day red and violet become more prominent. After sunset we see only the light which is reflected from the sky. The blue is lightest where the sun has set. If there are clouds there, they are coloured red and violet. Late sunlight shines on the underside of the clouds.

When working outside, we must certainly take into account the fact that daylight changes frequently. Because of this, a piece of work which cannot be completed in one sitting is best finished on another day at the same time and under the same weather conditions.

A PHOTOGRAPHIC COMMENTARY ON DAYLIGHT'S MANY MOODS

It has already been remarked that daylight can give the landscape a different atmosphere and mood and that this is dependent on the place, the time of day, the season and the weather conditions. The influence of daylight is clearly conveyed in the following photographic commentary, in which the same scene was photographed at different times of the day. It was made in Amsterdam between 7 am and 7.30 pm on a predominently sunny day in February.

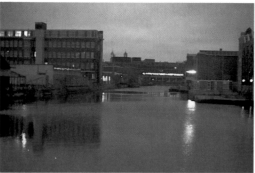

I 7 am.
On this early morning in winter the light is grey/violet, an almost unreal colour. This influences the whole scene. There is a thin cloud cover and the sky is a little lighter due to the reflection of light as dawn is breaking. There are practically no shadows. The light is still quite uniform. The water surfaces, the lighting and the contours of the buildings, which stand out against the sky, provide the only contrasts.

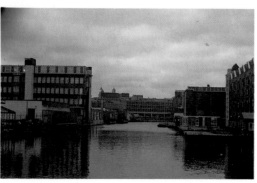

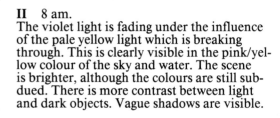

II 8 am.
The violet light is fading under the influence of the pale yellow light which is breaking through. This is clearly visible in the pink/yellow colour of the sky and water. The scene is brighter, although the colours are still subdued. There is more contrast between light and dark objects. Vague shadows are visible.

III 11.30 am.
Direct sunlight is visible because the clouds
have completely dispersed. In this photograph
the sun is coming from the left, and can be
observed falling on the facades of the ware-
houses and on the quayside on the right. Un-
der the influence of the red/yellow rays of
light which have now broken through the
scene is warmer and the colours are more
intense. Even the white walls are influenced
by the red/yellow light.
 At this time of year, daylight remains pink
because the sun is low. This is particularly
noticeable in the water and the blue areas of
sky. The shadows, which are long due to the
low altitude of the sun, are slightly blue/violet
in colour. Notice the long shadow of the lift
shaft on the building to the left.

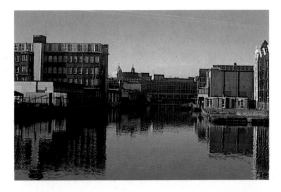

IV 2 pm.
Even in the afternoon, the light retains its
rosy glow when the sun is shining. The sun-
light, a little subdued because of the cloud
cover, is reflected from the clouds passing
overhead.

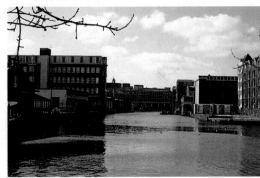

V 4.30 pm.
At the end of the afternoon the blue rays have
completely disappeared from the light so that
red/yellow light is predominant. The rays of
the sun are filtered through a thin cloud cov-
er. Because the sun is so low, everything
appears blacker and the contours are sharper.
The original colours are no longer easy to
distinguish and details are no longer clearly
recognizable.

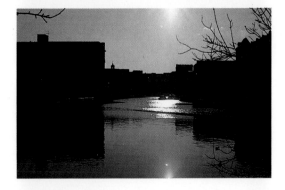

VI 5 pm.
The late afternoon sun is about to disappear
behind the houses and its red/violet light is
reflected by the clouds. The overall colour
impression, however, is still orange/red. The
dazzling reflection of the sun in the water
has gone and details are therefore more easily
distinguishable.

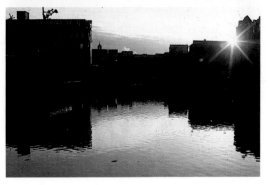

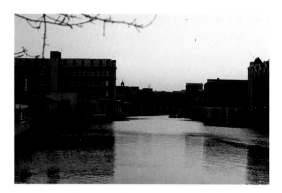

VII 5.45 pm.
The clouds have now completely dispersed
and the daylight is changing quickly. The sun
itself can no longer be seen, but the quayside
on the right still catches its last rays. Those
areas on which the sun does not fall directly
are much cooler in colour.

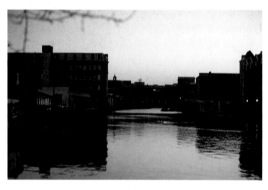

VIII 6.30 pm.

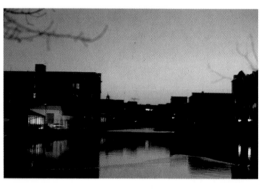

IX 7 pm.
Before night falls, violet light prevails. Then
the sun sets and all colour is absorbed until
it is resurrected at the dawn of a new day.

Light also plays an important role inside
the house. A room facing north seems
cool because not much long wavelength
red and orange light penetrates. Many
artists prefer to work in a north-facing
studio because there the impression of
colour is clearest.

A south-facing room, where the sun
penetrates for the larger part of the day,
on the other hand, seems warmer and
brighter.

In rooms facing the west and east,
red/yellow light predominates in the
morning and evening respectively (the
rising and setting of the sun), so that at
these times of the day they seem warmer.

THE LIGHT IN PAINTINGS

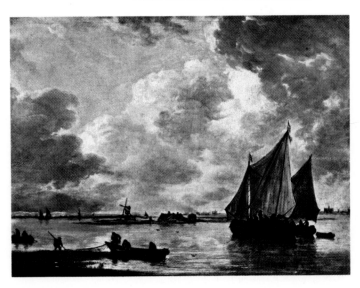

Haarlemmermeer
– 1656
JAN VAN GOYEN

Van Goyen made this painting in the last year of his life. Many times in his life van Goyen managed to capture the Dutch landscape, with its often enormous layers of clouds. The colour of the water is influenced by the reflection of the light shining on it.

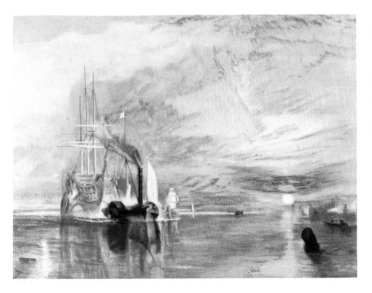

Fighting Téméraire
– 1839
JOSEPH WILLIAM TURNER

The late afternoon sun bathes the shore and the sea in a reddish orange glow. Turner was renowned for his brilliant, glowing light. Red, orange and yellow were his favourite colours.

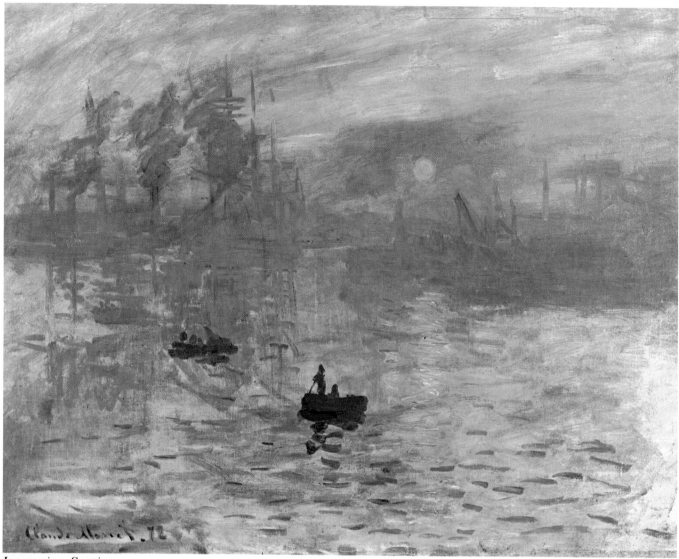

Impression, Sunrise
– 1873
CLAUDE MONET

It was the Impressionists, particularly, who captured the impression of colour in light, and by so doing freed themselves from the natural colour in normal daylight. This painting was made in the early, still grey, morning light, at the moment the sun was rising. The reddish violet light is breaking through the grey.

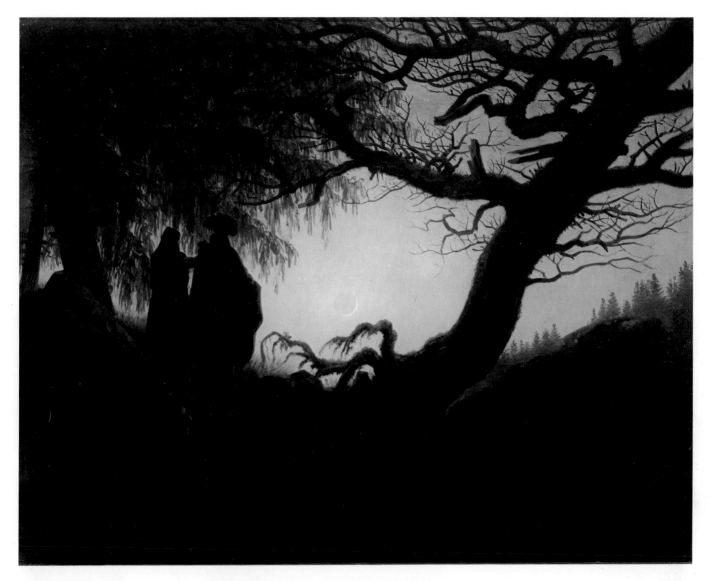

*Admiring the Moon
in Silence* – 1830-35
CASPAR-DAVID
FRIEDRICH

Friedrich made many paintings on the theme
of dusk, the setting of the sun and the rising
of the moon. He often directed the faces of
the people in his paintings towards the light.
Sharp contours are created in the foreground
(which he almost always kept dark) because
the light lies in the background of the paint-
ing. People and landscape are thus subordi-
nate to the mysterious light. Friedrich's work
is strongly symbolic.

ARTIFICIAL LIGHT

Because it is not always possible to draw or paint inside the house by daylight, we are often dependent on artificial light. This can present problems, particularly when working with colour. The light from a normal electric light bulb contains little blue and can therefore greatly influence the normal impression of colour. Because of the lack of blue light, yellow light predominates. (At first sight we do not experience this light as yellow light, but if we look into a room from outside we see that the light appears to have a yellow glow.) Blue and violet, colours in the short wavelength region, are greatly changed by electric light: they become grey and sometimes even appear black. In contrast, red, orange and yellow tints are activated by lamp light and appear to be more lustrous than they are.

It is obvious that electric light bulbs

An ordinary electric light bulb and a blue-coloured daylight bulb. The ordinary bulb gives a somewhat yellow light. The daylight bulb filters the yellow light out so that the light is closer to natural daylight.

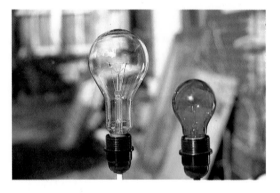

are not a good source of light if we wish to work with colour. Nowadays, however, there are various types of daylight lamps available in the form of light bulbs and fluorescent tubes. Seek expert advice. If you have the opportunity of installing a daylight fluorescent tube where you work, then choose the whitest available – this provides the closest thing to actual daylight. If you have no separate room in which to work and are dependent on ordinary room lighting, then purchase a daylight bulb. These blue bulbs almost eliminate long wavelength light.

COLOUR-BLINDNESS

When someone is colour-blind, he does not interpret the different wavelengths of light correctly. In contrast to what the term 'colour-blind' suggests – that colours cannot be distinguished – people who are colour-blind can, in fact, see colour; they simply experience certain colours in a different way. This disorder can occur at different wavelengths, so that a colour-blind person may confuse:

red and orange with yellow and green,

green and yellow with orange and red, or

green with blue and grey with violet or yellow.

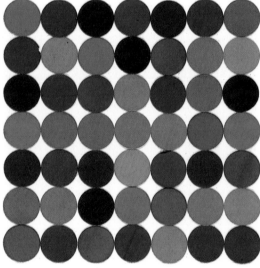

The colour-blind can confuse red and orange with yellow and green. They will not be able to distinguish the orange circles from the green.

Generally speaking, the problems of colour-blindness are recognized by our society. This is reflected particularly in road signs, which are designed to be easily recognizable. Prohibition signs, for example, are round, indication signs are square or rectangular and warning signs are triangular. Some traffic lights follow a regular sequence, and have a word such as 'Stop' or 'Go' added. There are also lights which show an image – the light at a pedestrian crossing, for example, shows a walking figure.

Artists who are colour-blind, indeed like any visual artist, rely upon their own impression of colour. The fact that they see colours differently presents no problem to them because they have never experienced the colours otherwise. The viewer sometimes notices the colour-blindness of an artist because a certain colour – such as green, for example – is missing from a series of works.

MIXING COLOURS

THE BASIC MIXING ASSORTMENT It is necessary to know how shades of colour are created, particularly if you are going to work with paint. If you have not yet concentrated on mixing colours, we recommend that you now master the practical application of mixing techniques. You can do this by making the colour circles (in which the creation of shades of colour is clearly expressed) described below and in the following pages, and by making the various colour test pieces in order to experience the effect of these shades of colour.

For this purpose Talens have put together a basic assortment of gouache paints. This consists of:

deep rose
lemon yellow
light blue
white
black

The assortment of gouache paints produced by Talens.

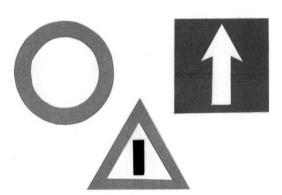

The colour-blind often recognize road signs by their shape.

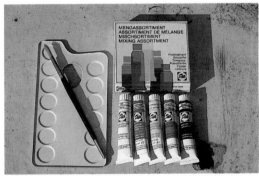

The deep rose – magenta – and the light blue – cyan – were chosen because they produce extremely pure shades of colour. They are also original printer's colours. We will use the above assortment for the colour test pieces.

Use a good quality drawing paper and a watercolour brush with a fine point. Number 8, made from hog's hair or filament, is very suitable. The gouache paint is thinned with water. You can measure out the amount of water added to the paint by using a pipette, which you can buy at the chemist. You also need a watercolour palette and a mixing tray. Always work with two jars of water; one to rinse out the brushes and the other containing clean water to add to the gouache. Change the rinsing water regularly so that the colours remain pure. Always rinse your brushes thoroughly. Traces of paint remaining between the hairs of the brush affect the shade you wish to make.

When mixing colours you must take two practical matters into consideration:

1) the mixing sequence. If, for example, you wish to make light green from yellow and blue, then begin with the lighter tint – yellow – and add blue to it. If you wish to make dark green, then begin with the darker tint – blue – and add yellow to it. By working in this way, you will find it unnecessary to keep on adding paint in order to achieve the shade you want.

If you wish to mix a series of colours ranging from dark to light – from blue to white, for example – then work first with blue and add increasing amounts of white to it. Midway through the series, change over. Begin with white and add blue to it. This method of working prevents you mixing too much paint before achieving the colour nuance you desire.

2) the colour intensity of paint. Not every colour has the same intensity. You will sometimes have to take this into account in a mixing ratio and use a little more, or a little less, of a particular colour. At first always carry out a small test in order to discover how a colour behaves in a particular mix.

THE SIX-COLOUR CIRCLE To make the six-colour circle, we begin with the three primary colours red, yellow and blue.

Set out these primary colours as shown below. Use dark pink, lemon yellow and light blue. A secondary colour is created by mixing two primary colours.

Orange is created by mixing yellow with red.

Green is created by mixing yellow with blue.

Violet is created by mixing blue with red.

The six-colour circle is complete and is therefore built up from three primary and three secondary colours.

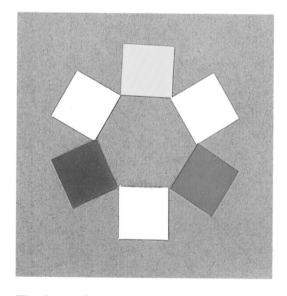

The three primary colours.

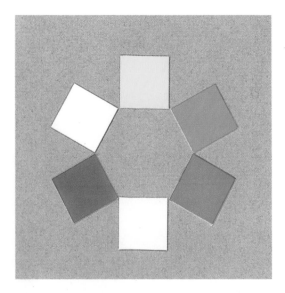

Orange is created by mixing red and yellow.

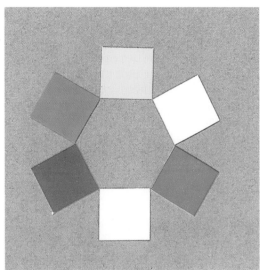

Green is created by mixing yellow and blue.

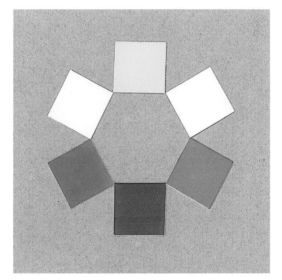

Violet is created by mixing blue and red.

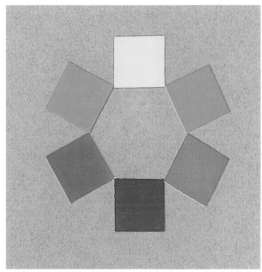

The six-colour circle. Each colour has a fixed position.

THE COMPLEMENTARY COLOURS IN THE SIX-COLOUR CIRCLE In the six-colour circle, two colours always lie opposite each other. Yellow lies opposite violet, red opposite green, and blue opposite orange. If we put these complementary colours next to each other, a strong colour contrast is created; because of this contrasting effect a small area of colour can dominate a much larger area of another colour.

Complementary colours placed next to each other contrast strongly. A small area of colour can dominate a larger area.

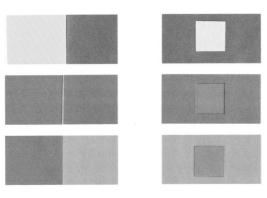

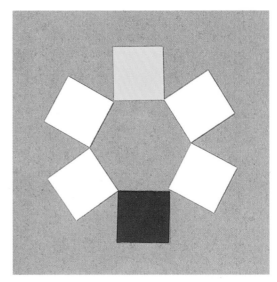

In a colour circle, complementary colours always lie directly opposite each other.

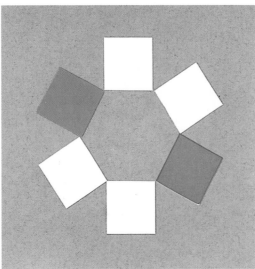

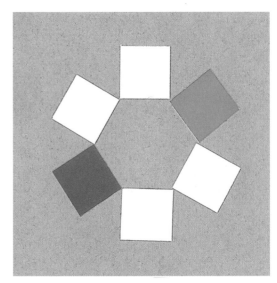

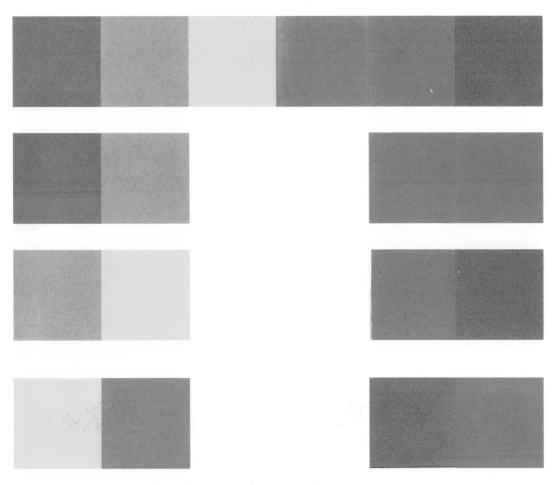

In an colour circle,
harmonious colours
lie next to each other.

HARMONIC COLOURS Besides pairs of
complementary colours, the six-colour
circle also contains pairs of harmonic
colours, the colours which lie next to
each other in the circle. They are less
contrasting than the pairs of complemen-
tary colours and give a certain harmony.

The six-colour circle contains six of
these harmonic pairs of colours:
 red – orange
 orange – yellow
 yellow – green
 green – blue
 blue – violet
 violet – red

In a colour circle, every colour lies between two other colours. This creates groups of three harmonious colours.

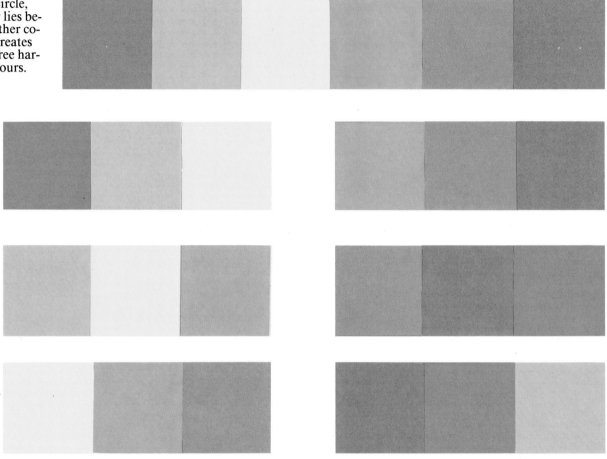

We can also make series of three harmonic colours from the six-colour circle – each colour now lies between two other colours:

red – orange – yellow
orange – yellow – green
yellow – green – blue
green – blue – violet
blue – violet – red
violet – red – orange

Colour

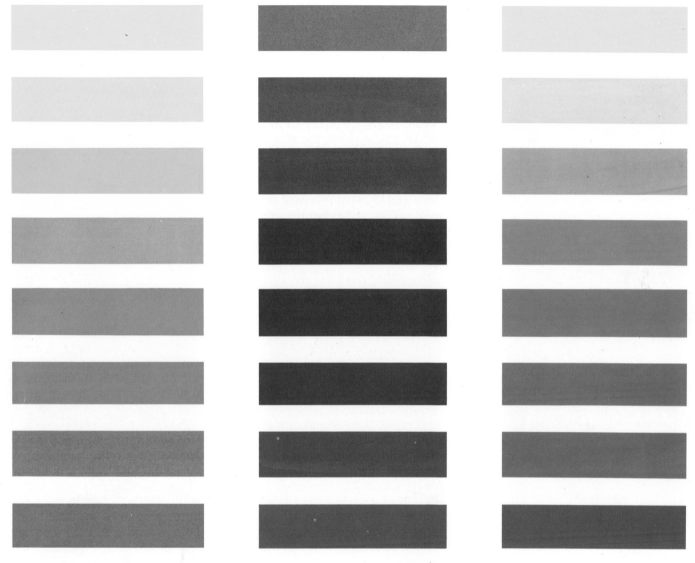

THE MIXING OF TWO PRIMARY COLOURS
If you look at the six-colour circle again, you will see that a secondary colour is mixed from two primary colours. From these two primary colours, however, a whole series of secondary colours can also be mixed. A primary colour moves to a second primary colour via the diverse secondary colour nuances. In this way we can make a series of colours between yellow and red, yellow and blue, and red and blue. The shades that are created depend on the mixing ratio and the purity of the colours:

1) by mixing together the primary colours yellow and red, a series of reddish-oranges, orange-reds, orange, orange-yellows and yellowish-oranges is created.
2) by mixing together the primary colours blue and red, a series of reddish violets, violet-reds, violet, violet-blues and bluish violets is created.
3) by mixing together the primary colours yellow and blue, a series of bluish greens, greenish blues, green, greenish yellows and yellowish greens is created.

THE NATURE OF THE PRIMARY COLOURS

Besides the purity of colour and the mixing ratio of the paint, the sort of colour series the mixing produces depends on the nature of the primary colour. If, for example, one of the primary colours red, yellow and blue (in this case magenta, lemon yellow and cyan) is replaced by a different red, yellow or blue, then this will influence the shades of colour which are created.

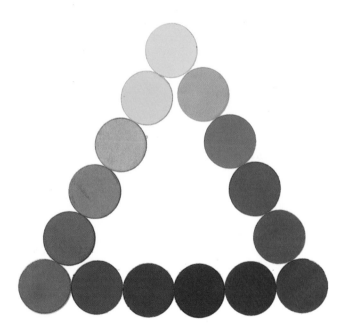

To make this colour triangle, the three primary colours magenta, lemon yellow and cyan were used, a combination which produces very pure colours.

If we replace cyan by ultramarine, then the greens especially become warmer. Because of the influence of the magenta, violet/aubergine tints are created when red and blue are mixed.

If we replace the magenta by vermilion however, browns, among other shades, are created when red and blue are mixed.

If the nature of all the primary colours is changed (here ultramarine, vermilion and cadmium yellow), then beautiful bronze greens, instead of bright yellowish greens, are created between the blue and yellow. All the shades mixed from these colours are much less vivid than those mixed from magenta, lemon yellow and cyan.

TERTIARY COLOURS A tertiary colour is created by mixing two secondary colours together. Every tertiary colour contains three primary colours.
To elucidate:
a) mixing green and orange, both secondary colours, produces the tertiary colour moss-green. Green contains the primary colours yellow and blue, orange contains the primary colours red and yellow. The tertiary moss-green therefore contains the three primary colours red, yellow and blue.
b) mixing orange and violet, both secondary colours, produces the tertiary colour orange-reddish brown. Orange contains the primary colours red and yellow, violet contains the primary colours blue and red. The tertiary orange-reddish brown therefore contains the three primary colours red, yellow and blue.

c) mixing violet and green, both secondary colours, produces the tertiary colour bronze green. Violet contains the primary colours blue and red, green contains the primary colours yellow and blue. The tertiary bronze green therefore also contains the three primary colours.

Of course, different nuances are created by changing the mixing ratio.

Mixing, however, can also go wrong so that a drab, muddy colour is created (see below, the last colour of this series). We must look for the cause of this in the powers of absorption and reflection of particular colours.

To elucidate:

Violet, a colour from the short wavelength region, absorbs all the colours of the spectrum except violet, which is reflected. If we mix this violet with, for example, green, then that green can also be absorbed by the violet and thus nullified. Looking at this the other way round, green reflects the green rays of the spectrum and absorbs the rest. This means that when green and violet are mixed, the violet rays are also absorbed by the green. If the colour were mixed in the wrong proportions, all the rays of

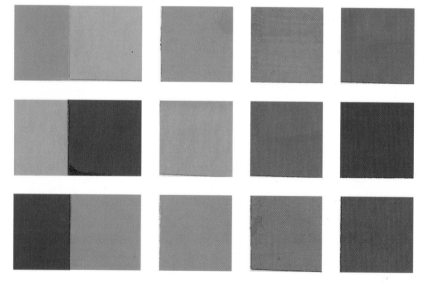

the spectrum would be absorbed, and the resulting colour would be perceived as a drab black. It is clear that the mixing ratio is very important to obtain a good shade of colour, and that good mixing requires a great deal of experience.

A tertiary colour is created by mixing two secondary colours together.

THE TWELVE-COLOUR CIRCLE To make the six-colour circle you have already mixed two primary colours together to produce a secondary colour, so that six colours resulted. These six colours can be increased to twelve by continuing to mix a primary colour with a secondary colour.

To do this set down the six-colour circle so that there is space to apply the newly-mixed colours between the already existing colours.

Now mix yellow and orange and lay the resulting colour between these two. Mix the other shades and lay them in the appropriate place. To do this, mix consecutively orange with red, red with violet, violet with blue, blue with green, and green with yellow. Make sure the mixing ratio is correct so that there is an even transition from colour to colour.

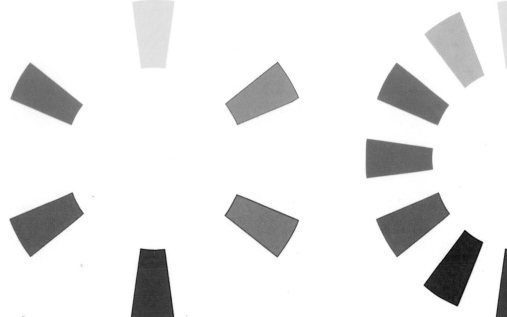

The six-colour circle is built up from three primary colours and three secondary colours.

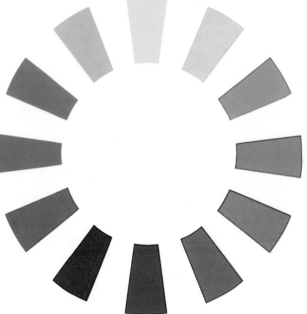

The twelve-colour circle.

THE TWENTY-FOUR-COLOUR CIRCLE

Finally, we shall increase the circle to twenty-four colours. As you will have observed, such a colour circle is of great assistance in mixing colours. You can see at a glance how a particular colour is created.

Begin with the twelve-colour circle, mix the first colour with the second and lay the resulting colour between these two. Continue in this way, mixing the second colour with the third, the third with the fourth, the fourth with the fifth, and so on, until the circle is complete. Again, ensure that there is an even transition from colour to colour.

COMPLEMENTARY COLOURS IN THE TWENTY-FOUR-COLOUR CIRCLE

Every colour has its complementary colour. In the six-colour circle it is obvious that the complementary colours of red, yellow and blue are, respectively, green, violet and orange. These complementary colours lie opposite each other in the circle.

No matter with which colour circle you work, every colour can be found directly opposite its complementary colour. The complementary colours can easily be found by laying a ruler through the centre of the circle.

There are a few other methods of bringing the colours closer together so that their effect can be seen more clearly.

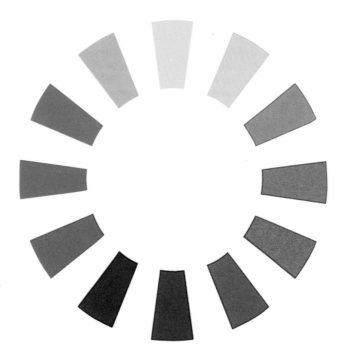
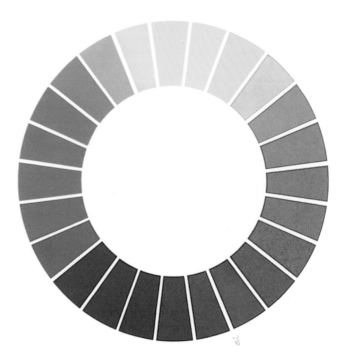

The twenty-four-colour circle.

Method I Carefully cut out a small ring from a colour circle and glue it to a piece of paper. Do this so that the primary colour yellow lies in the middle at the top – the position of the 12 on a clock face. Glue the remaining part of the colour circle in this ring so that the primary colour yellow lies in the position of the 6 on a clock face. Yellow now lies opposite violet, just as every colour now lies opposite its complementary colour.

Method II Make a dial from your colour circle. To do this, again cut a ring from the circle and glue it to a piece of heavy paper or thin cardboard. Glue the remaining piece to a similar piece of paper or cardboard. Cut out both circles round the outer edge and mark the centre points. Lay the smaller circle on the larger and fix them together with a split pin.

This dial has two functions. It can be used as a colour circle to find how a shade of colour is created, and to find complementary colours. A third function will be added later.

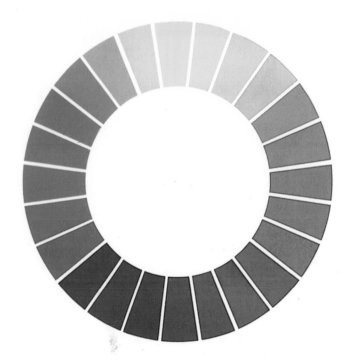

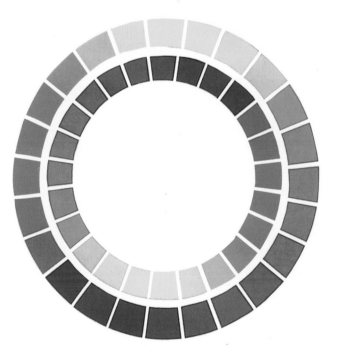

All the complementary colours lie close together.

BREAKING UP OF COLOURS It is possible to build up a very large number of colours by mixing together primary colours and the colours they themselves create. This assortment becomes still greater if we break up the colours by mixing. By breaking up of colours we mean the toning down or darkening of colours by mixing. This process creates light and dark tints which can be very valuable in our work.

Colours can be toned down or darkened in different ways:
1) by mixing with white
2) by mixing with black
3) by mixing with grey
4) by mixing them together

TONING DOWN COLOURS WITH WHITE Colours can be made lighter by toning them down with white. A colour can be continuously toned down by mixing it with still larger quantities of white.

The original colour remains visible for a long time as increasingly softer pastel tints are created.

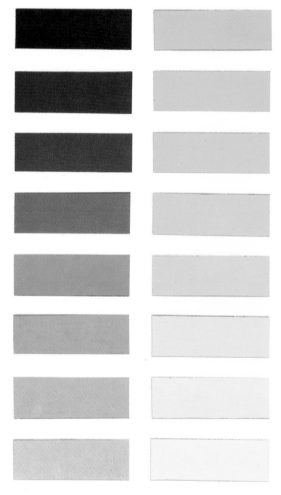

Brown and yellow toned down with white.

DARKENING COLOURS WITH BLACK

Colours can be made darker by mixing them with black. The greater the amount of black with which the colour is mixed, the darker it becomes. The original colour can be changed by this process (when yellow is darkened, for example, it acquires a greenish tint due to the influence of the black), but generally speaking, the original colour can still be easily recognized.

The combinations of colours in such a series are always in harmony with each other because they all contain the same original colour. This is true not only for combinations of softened tints, but also for the darkened tints in a series of colours. For the same reason colours which are toned down as well as darkened go well together.

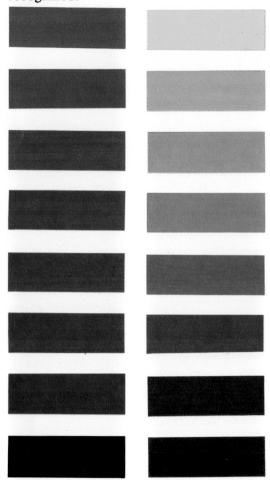

Blue and yellow darkened with black.

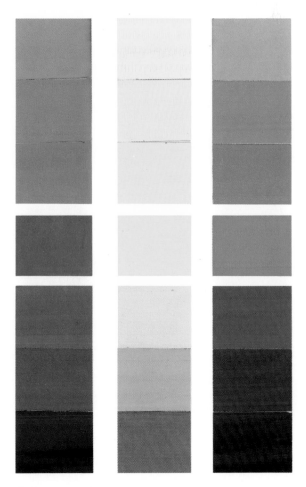

Colours can either be toned down or darkened.

THE INFLUENCE OF GREYS FROM WHITE AND BLACK White and black can also be broken up by mixing them together. A series of greys is created, and these greys can again be used to break up all the various other colours. These colours then acquire a greyish tinge. The influence of grey on a colour depends on the particular nuance of grey and the ratio in which it is mixed with the original colour. The decline in the purity of the colour differs. Mixing colours with grey produces more subdued colours than darkening them with black. This is clearly visible in the illustration on page 45. Compare the results of mixing an original colour with dark grey and with black.

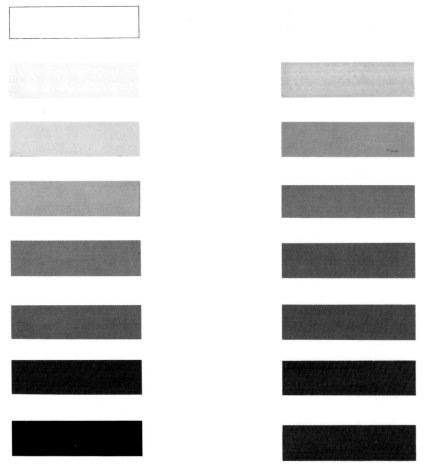

White and black can also toned down or darkened by mixing them together.

If the dark grey created by mixing the three primary colours is toned down with white, the nature of the grey changes.

THE INFLUENCE OF THE MIXING OF
COLOURS ON COLOUR PURITY Colours
can not only be toned down and dark-
ened by mixing them with white, black
or grey, but also by mixing them togeth-
er. In this case, the colours are so strongly
affected that the original colours are
scarcely recognizable. Darker colours
are created because the rays of light from
the colours which are mixed are almost
all absorbed. (See p. 40, Tertiary
Colours.)

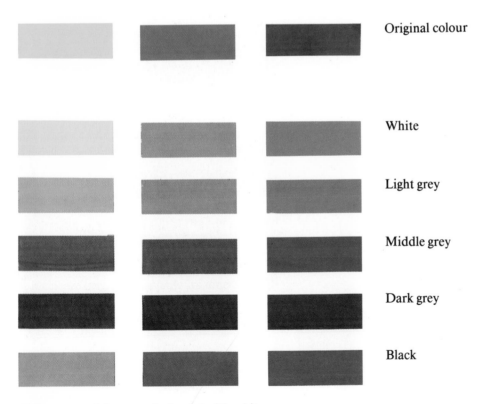

Original colour

White

Light grey

Middle grey

Dark grey

Black

Colours toned down or darkened with white
or black are brighter than colours toned down
or darkened with grey.

Colours which are mixed with their complementary colour immediately lose their purity. Dark tints are created. Here, too, the mixing ratio influences the colour nuance. The three primary colours red, yellow and blue are also strongly affected when they are mixed together. When mixed they produce a dark tint which we experience as dark grey. If we soften this visual grey with white, it appears that the primary colours with the greatest colour intensity influence this series of greys (see page 46). In this case it is the red and the blue colours which together give a violet tone to the greys. The yellow has no influence on the colour nuances and is completely absorbed.

The 'endurance' of a colour on mixing is known as 'colour intensity' or 'colour saturation' and is related to the content of pure colour in the paint. A colour which quickly loses colour when mixed with white, for example, has little colour intensity. The colours of the spectrum are all saturated colours and therefore have great colour intensity. The range of colours is considerably increased by toning down and darkening colours. These tints are very useful for depicting feelings and moods – the atmosphere of late evening, for example – and for applying areas of shadow.

Colours mixed with their complementary colours quickly lose their purity.

Mixing red, yellow and blue together gives a grey/black colour.

COLOUR INFLUENCES

THE INFLUENCE OF COLOUR ON CONSCIOUSNESS Colours have an influence on our consciousness and therefore we often surround ourselves with colours that make us feel good. Preference for a particular colour or colours is very personal and finds expresssion in, among other things, our clothing and the interior of our homes.

Colours have different qualities. We experience them as warm or cool, cheerful or sombre, striking or unobtrusive, restful or restless. In general, we can state the following about the influences of different colours:

RED dynamic, activating, striking, restless, vivid; red demands attention and radiates warmth.

ORANGE has approximately the same influence as red. It is a little less activating, however, but still demands attention and radiates warmth.

YELLOW cheerful, joyful, bright, warm. (Together with red and orange, the colour of sunlight. It is also – with red – a colour much used in the manufacture of children's toys.)

GREEN restful, does not dominate (surgeons' gowns, traffic lights, snooker tables).

BLUE cool, restful, spacious (bedrooms, waiting rooms, consulting rooms).

VIOLET sober, sombre, stately, distinguished, serious, contemplative (an ecclesiastical colour, auditorium).

Colours influence our feelings. Colour preference is a very personal matter.

THE FINE ARTS SERIES

WARM AND COOL COLOURS We can also divide colours into those which are warm and those which are cool. Red, orange and yellow are warm colours; cool colours are chiefly found among the blues; green and violet are both colours which are neither warm nor cool. Green contains warm yellow and cool blue, neither of which dominates; violet contains warm red and cool blue, and again, neither dominates.

Whether a colour strikes us as warm or cool depends on its colour nuance.

To elucidate:

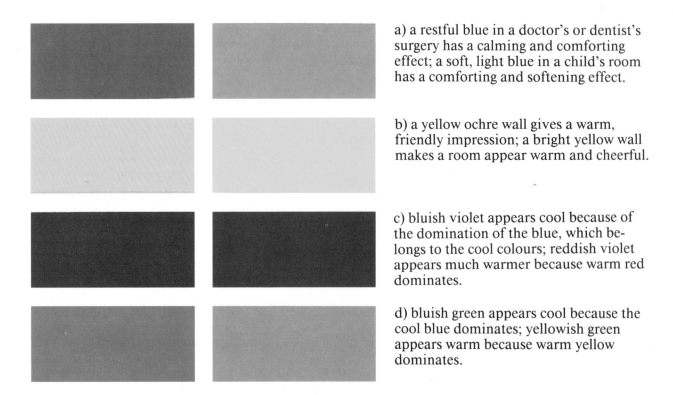

a) a restful blue in a doctor's or dentist's surgery has a calming and comforting effect; a soft, light blue in a child's room has a comforting and softening effect.

b) a yellow ochre wall gives a warm, friendly impression; a bright yellow wall makes a room appear warm and cheerful.

c) bluish violet appears cool because of the domination of the blue, which belongs to the cool colours; reddish violet appears much warmer because warm red dominates.

d) bluish green appears cool because the cool blue dominates; yellowish green appears warm because warm yellow dominates.

Colour

When colours are placed next to each
other, our original impression of them
can change because the colours influence
each other.
　　To elucidate:

a) blue and violet appear cool because
of the influence of the blue which domi-
nates the non-dominant violet.

b) blue and green give a cool impression
because of the influence of the blue and
the blue in the green. The green does not
stand out.
　　Yellow and green give a warmer im-
pression than blue and green because of
the influence of the warm yellow and the
yellow in the green.

c) whether the colours appear warmer
or cooler in a colour combination also
depends on the colour nuances used. A
harsh green and a vivid yellow give a
cooler impression than a soft green and
a warm yellow. Warm yellow contains
red; red is a warm colour and therefore
influences the combination. Light green
contains a lot of yellow, which is also a
warm colour, and therefore also in-
fluences the combination.

d) greys can appear warm or cool, the
greys in this illustration contain, from
left to right, blue, yellow and red.

Warm and cool colour
combinations.

COLOUR AND ILLUSION Colours placed next to or over each other affect each other. They can complement, accentuate, repel or absorb each other. When working with colour, you will be continually faced with this fact. By investigating the effect colours have on each other you will eventually be able to bring about the exact colour effect that you want.

The success of your piece of work will largely depend upon the effect of colour.

How strong the influence of a colour on a surrounding colour can be will become clear if you lay small circles of paper of the same grey tint on planes of different colours. If you examine the colours through half-closed eyes, concentrating on the grey circles, you will be able to observe clearly the different colour influences. The grey circle on the orange plane, for example, appears much darker than the other circles. If you separate the different colours, it will strike you that each neutral grey circle takes a little of the colour complementary to the colour on which it has been placed. The grey on the orange plane therefore seems a little blue; the grey on the red plane seems a little green; and the grey on the blue plane appears warmer than the others because it seems to have an orange aura. The grey circle on the black plane gives the purest impression of colour.

Neutral greys have no saturation degree, because, like black, they contain no colour.

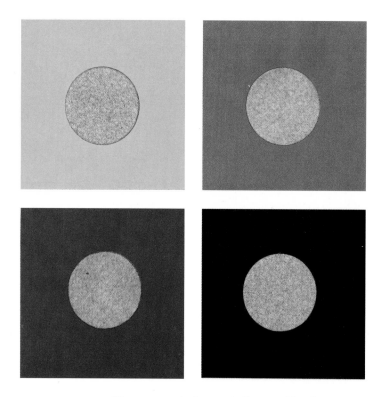

These grey circles are influenced by the surrounding colour.

Because every colour has its own nature, two planes of colour of equal size can be out of balance with each other.

To elucidate:

If you lay the warm colour orange and the cool colour blue next to each other in the same proportions, the orange will stand out and the blue will recede. If you make the dominant orange area a fraction smaller, the whole area of colour is brought into balance.

Do the same thing with blue and grey. When the areas of colour are equal, blue now appears to dominate. To bring the area of colour into balance, the blue plane must be reduced.

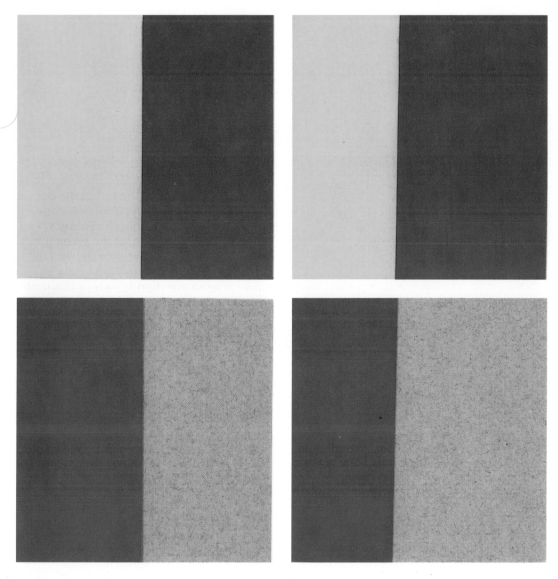

Colours have different intensities. In order to bring an area containing more than one colour into balance, the colours must be brought into balance with each other.

Bringing areas of colour into balance is not quite as simple as it might seem, as can be seen in the illustration below.

a) The violet circle dominates the grey plane. If you lay a grey circle on a violet plane, the violet plane will also dominate. The neutral grey has no influence whatsoever on the colour.

b) In the case of the green plane and the red circle, it is the red circle which dominates, despite the fact that it covers a smaller area. One could even say that the green plane accentuates the red circle.

The green circle on the red plane dominates the red as far as intensity is concerned because here, too, the colours accentuate each other and the green appears more vivid than it actually is. Due to the strong contrast, the red circle appears to be bigger than the green circle.

c) The circles on the orange planes give an example of how combinations of colour can be absorbed or appear to recede into a surrounding colour. The green circle stands out strongly in the orange plane and the light brown circle is partly absorbed by the orange.

THE EFFECT OF COLOUR AND ITS BACK-
GROUND We can also work with the
illusion of colour within our own homes.
We can, for example, make a narrow
room appear wider, or a wide room ap-
pear narrower, by giving a wall, the ceil-
ing or the floor a particular colour.

How well the use of colour must be
considered beforehand can be seen in
the following examples. They are, per-
haps, rather extreme examples, but they
demonstrate the effect of colour very
clearly. When designing a piece of work,
you will often have to choose a colour
for the background of a still life, a por-
trait, and so on. It is therefore necessary
to have an insight into these materials.

THE RED/BLUE CORRIDORS

a) Red is a colour which stands out,
and blue, one which recedes. Both red
walls attract the attention and therefore
make the corridor seem narrower. The
blue floor, rear wall and ceiling recede,
so that the ceiling seems higher and the
rear wall appears further away than is
actually the case. The colours contrast
strongly and the effect of colour is there-
fore strengthened.
b) The blue walls recede so that the cor-
ridor seems wider than corridor a. The
red rear wall is prominent, and the red
floor and ceiling seem to approach each
other. The corridor seems lower than
corridor a. The red door appears narrow-
er and higher than the blue door.

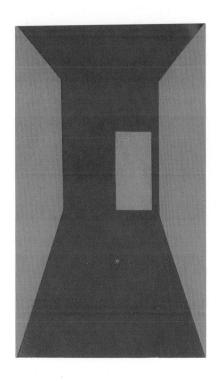 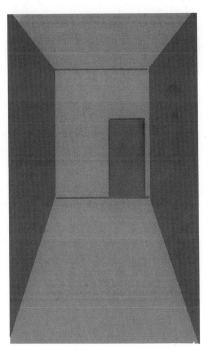

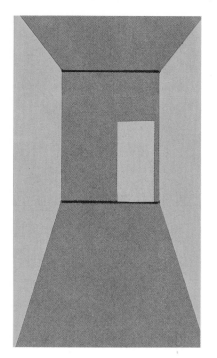 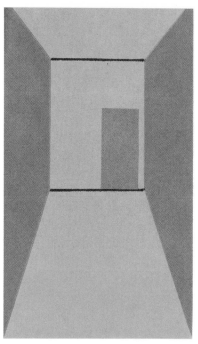

THE ORANGE/BROWN CORRIDORS

Two harmonious colours, both of which contain yellow and red, rather than contrasting colours such as red and blue, were used for these corridors. This gives a much more restful colour effect. Nevertheless, just as in the red/blue corridors, an effect of (colour) dominating and receding is also created here.

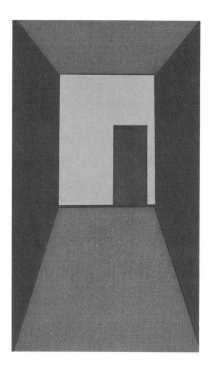 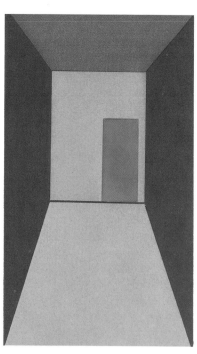

OVER-ABUNDANT USE OF COLOUR

a) An over-abundant use of colour can quickly bring about disharmony, even when colours which go reasonably well together are used. Although in principle the orange rear wall is in harmony with the red floor and the red ceiling, it still stands out strongly. Moreover, the blue walls (blue is the complementary colour of orange) contrast much too strongly and therefore give the whole corridor a feeling of restlessness.

b) If colours are used indiscriminately, every effect of colour is nullified. There is no unity and the whole becomes un-interesting. Limitation of colour clearly should have been applied here.

Colour

THE GREEN CORRIDORS

a) Not only are the colours limited in these corridors, but colours of the same sort have been used. The light green colour of the walls is carried forward into the ceiling and this, together, with the influence of the dark green, gives a tunnel-like effect of depth.

b) This corridor seems much wider than corridor a because the dark green walls recede. The light green, however, seems to raise the floor.

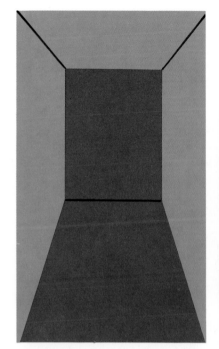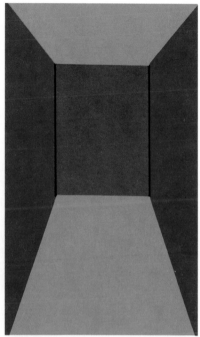

THE EFFECT OF BLUE

a) In this corridor the blue walls and floor recede so strongly that the rear wall seems to float. Moreover, this orange wall stands out strongly. The corridor loses its limitations, as it were, because of the receding blue.

b) It seems as if the black of the floor is holding onto the orange rear wall. Because of the blue ceiling and walls, the corridor seems narrow and short. This is accentuated by the dominant orange.

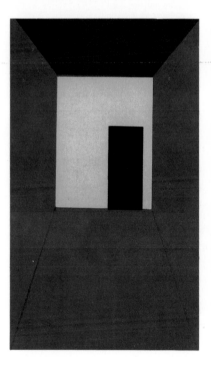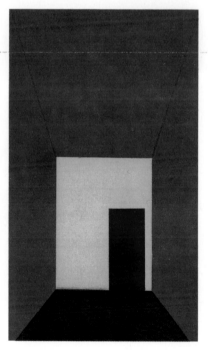

In general, people are quickly inclined to give a particular interpretation to a particular colour. The illustrations on this page are good examples of this. The colour composition in the first illustration conjures up for many an association with water and land. We assume colour association which we have learned: grass is green, water is blue, a roof is red, and so on. This picture could be a stream through a meadow.

In this composition the colours have been changed. What was first meadow now invokes an association with water due to its blue colour. One could imagine a dike across a lake.

From all the foregoing examples, it emerges that in drawing and painting due consideration must be given to the effect of colours. Ensure that your subject always attracts the attention, and that the attention is not distracted by attention-demanding colours. You must ensure that a subject forms a harmonious unity with the background and that it is not completely swamped by it.

COMPOSITION

BALANCE IN A PLANE

Most people at first associate 'composition' with a piece of music. The word 'composition' literally means 'assembly' or 'construction' and that is what a piece of written music is: an ordered assembly of certain musical elements such as staves, notes and rests. When we hear a performance of such a composition, it conjures up various emotions and images. That was the intention of the composer. His composition may be playful and lively, romantic and full of atmosphere, moving or even frightening and menacing, but regardless of the atmosphere which he creates, a composer will always try to bring harmony to his work so that the listener will understand what he is trying to say. The word 'composition', however, does not only apply to music. It also applies to the visual arts, because every drawing, every painting, is basically a composition: an assembly of pictorial elements.

The question is: what is a good composition? This is a question to which there is no definitive answer, because both creating and judging a piece of artwork is largely a matter of personal taste. This also applies, of course, to the determination of composition. This is basically a matter of feeling, of personal choice and preference. Actually, all of us 'compose' in our everyday lives. Unconsciously, often unwittingly and automatically, we assemble and order things every day. This is demonstrated in almost everything we do: the combination of colours in our clothes, the organisation of writing materials and papers on our desk, the layout of our homes, the combination of colours in the interior, the arrangement of a bouquet of flowers, the way we plant a garden, the arrangement of pots and pans on a shelf, even the way we hang up the washing! These are all operations which involve composition and in which one or more pictorial elements are employed. A feeling for composition is more strongly developed in one person than in another. Such a feeling, however, can be further developed with practice.

Moreover, looking at paintings and good photographs, and making your own trial pieces, will also help. You not only learn to recognize balanced compositions, but gradually you also learn to notice more quickly when a composition is unbalanced, dull or excessive. The following illustrations form a simple, yet clear, example of this.

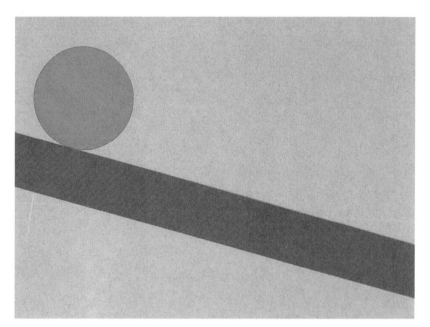

I The ball lies on a beam in the left-hand side of the picture. The beam lies diagonally, and this suggests the idea that the ball is about to roll into the picture, so creating movement in the composition. This suggestion of movement ensures that the bare area on the right-hand side has a function. The composition is therefore in balance.

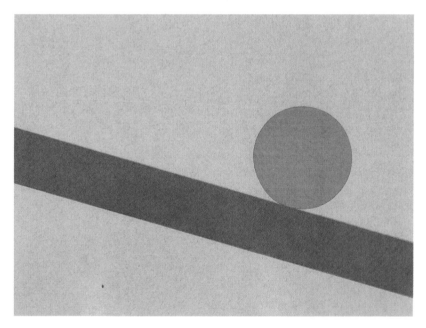

II The ball has passed the centre of the beam. It has lost the momentum which it had in the first situation, but because of its position on the beam, it counterbalances the large area on the right. The sloping line of the beam on the left helps to keep the whole picture in balance.

III The ball hits the edge of the picture and its progress is halted. The momentum has now been completely lost. The ball still has a function, however, in holding the picture in balance. The sloping beam on the left still contributes to the overall balance. This composition is not unbalanced, but there is a lack of tension because so little is happening in the picture.

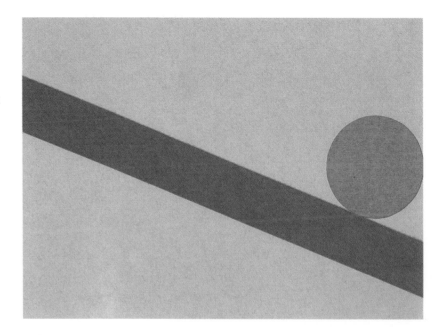

IV The ball has rolled out of the picture and now has no function whatsoever in the composition. The beam alone can not ensure that there is balance in the picture. Emptiness has been created and the relationship between the beam and the ball has disappeared. The composition can be regarded as bad and without purpose.

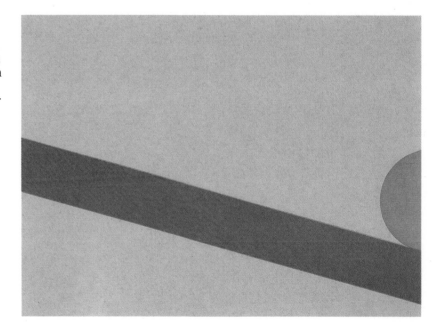

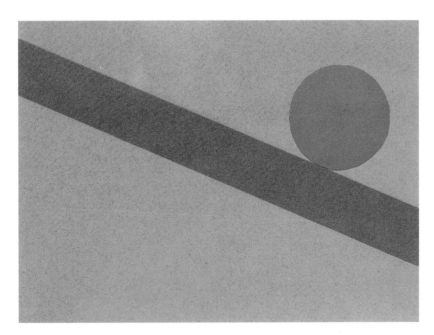

V It can be seen from this example that changes cannot be made in a balanced composition without adverse effects. At first glance, it appears that the same situation exists as in illustration II. Here, however, the beam is situated in a higher position, so that a large empty area is created in the bottom left-hand corner of the picture. This area no longer has a relationship with the beam. The whole is therefore not in balance.

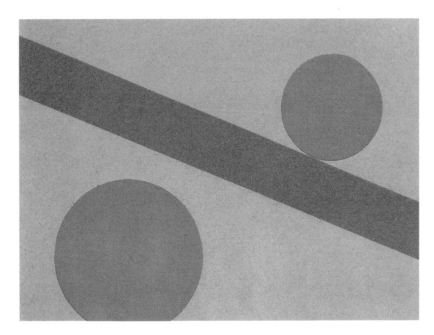

VI This is the same situation as in illustration V, but now a ball has been placed in the foreground. Because of both its size and its striking colour, the ball exercises a large influence and this pulls the composition back into balance. Both grey areas now contain a proportionate amount of red and the composition is once more a unity.

DIVISON OF A SURFACE BY MEANS OF CONSTRUCTION LINES AND SHAPES

I Methods of promoting balance in a composition by division of the surface area, so that a drawing or painting can be built up as harmoniously as possible, were devised long ago. Among other things, artists arrived at the idea of using the straight and diagonal line, the triangle and the rectangle, the L-shape and the circular form.

The illustrations II to VI inclusive enable you to identify a few of these forms.

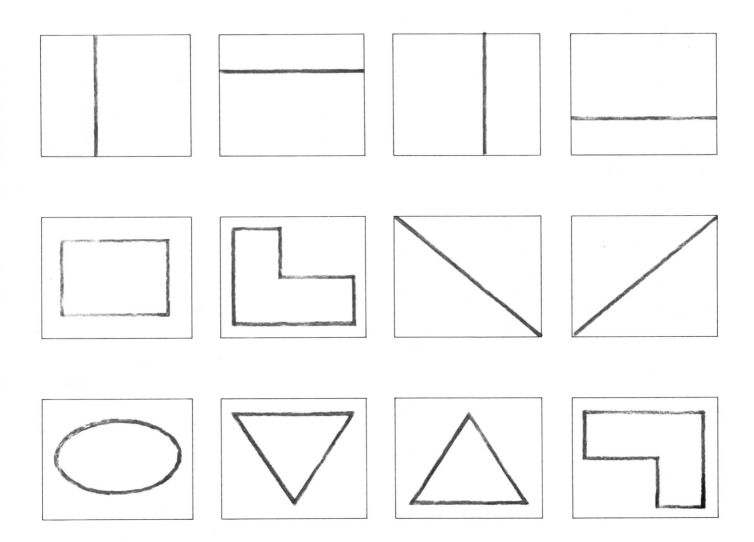

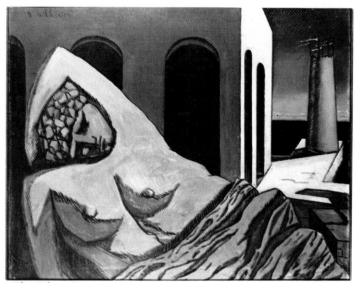

The Silent Statue
– 1913
GIORGIO DE CHIRICO

II Giorgio de Chirico positioned his subject in a simple diagonal division of the plane. The picture occupies the whole of the lower diagonal area. In the upper area he principally used vertical lines.

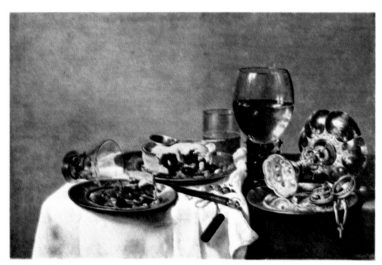

Still Life – undated
WILLEM CLAESZ
HEDA (c. 1593-1682)

III In this still life, Willem Claesz Heda also used a diagonal line, which he largely placed in the lower area. The picture is in balance; Heda did not need to provide a counterbalance in the second area.

IV A composition can also contain more than one diagonal line. In this trial piece, it is the planes of colour which create the diagonal effect. They also determine the movement. The direction of the movement can easily be observed by following the diagonal lines.

V This trial piece also contains several diagonals. Here they direct the movement upwards.

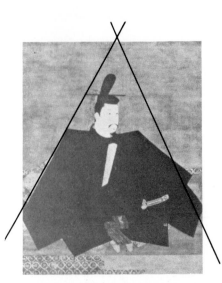

VI The triangle is a shape which is often used as a basic form, particularly for portraits. In this beautifully balanced Japanese drawing, executed on silk, the portrait is placed firmly in the triangular shape.

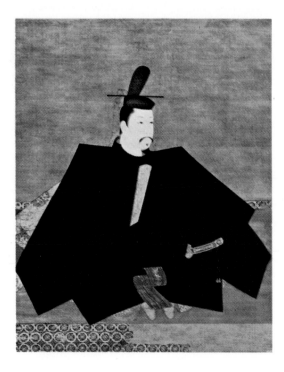

Portrait of Minamoto Yoritomo – undated
FUJIWARA TAKANOBU (1142-1205)

Nude Seen from the Back – undated
JEAN AUGUSTE DOMINIQUE INGRES
(1780-1867)

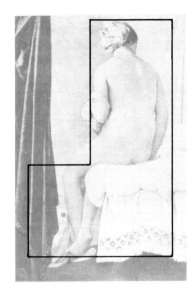

VII-VIII The L-shape has been used frequently as a basic shape in a composition.

The vertical and horizontal lines, or conversely the horizontal and vertical lines, of objects placed in an L-shape, are held in balance. How this shape is used can be seen in both illustrations.

Girl on a Ball – 1905
PABLO PICASSO

In both paintings, the L-shape is used for composition.

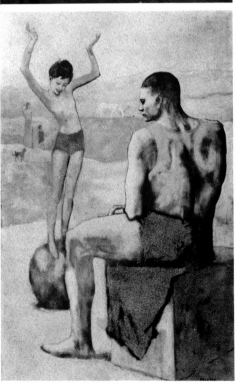

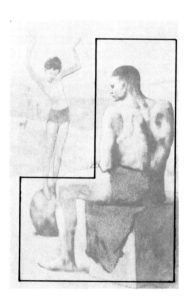

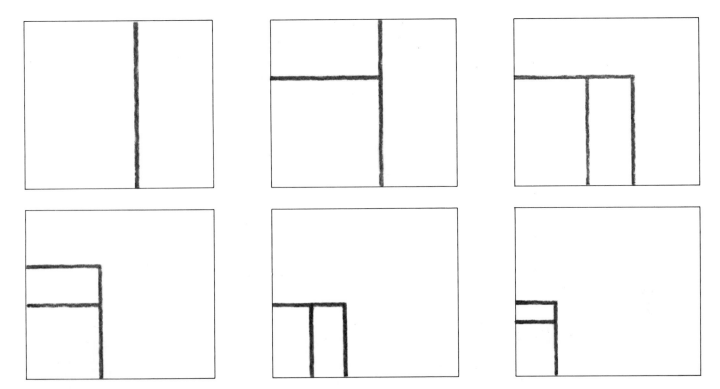

As we have demonstrated, a good composition can be created by using geometric shapes or particular lines which divide up the area of the working surface.

The ancient Greeks held the view that art was only art if a shape or an image was in perfect harmony. They declared this perfect harmony mathematical, because it was created by means of mathematical calculation. This calculation, which has been applied for centuries, is known as the *Golden Section*. This Golden Section can be found in many old paintings. It is still used nowadays in architecture, in advertising and to determine the format of paper and books.

IX The principle of the Golden Section: if a plane (format) is divided in the proportion 3:5, 5:8, 8:13, 13:21, etc., the smaller of the two resulting areas will be in the same proportion to the larger area as the larger area is to the original plane. A simplification of this mathematical calculation is to multiply the longer side of the plane (format) by 0.6.

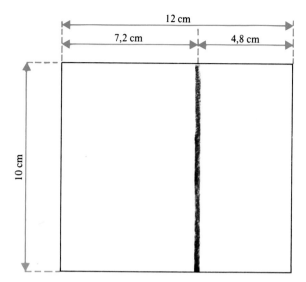
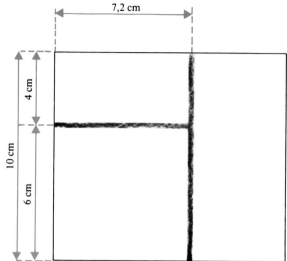

X Example:
We begin with a format of 10cm x 12cm. The longer side is 12cm. 12 x 0.6 = 7.2. We now measure 7.2cm along the longer side and draw a line, thus dividing the area in the proportion of 3:5 and applying the Golden Section principle.

The area can be still further divided. To do this, we start with the larger area created by the first division. The longer side of this area is now 10cm. 10 x 0.6 = 6. The dividing line is therefore placed at a height of 6cm. Every area can be subdivided in this way (see the illustration above).

COLOUR AND COMPOSITION

Colour is the most important pictorial element in painting and in pastel drawing. Choice of colour is highly personal and many artists can be recognized by their palette. Turner, for example, had a preference for warm colours like red, orange and yellow and Picasso had his pink and blue periods. In order to promote harmony in the work, the colours must be brought into balance with each other. We have already seen that colours lying next to each other in the colour circles harmonise with each other, as do the colours from the series created by mixing two colours together, or by mixing them with white, grey or black. These colours have little contrast. This is known as *relative contrast*.

In the colour circle, however, there are many more colours which can be in harmony with each other. Many people have an instinct for knowing whether colours harmonise or not, others will need a little assistance.

When employing harmonic colours, we take *colour tones* as our point of departure. A colour tone combination consists of a number of harmonious colours: a two-tone combination consists of two, a three-tone of three, and a four-tone of four colours which *can* be in harmony with each other.

These colour tones can be found in the twenty-four-colour circle by using indicators. (Combinations of more than four colours are possible, but this is straying too far from the topic. If you plan to use four-tone combinations, extended harmonic colour combinations will not present any problems.)

Two-tone combination Three-tone combination Four-tone combination

a) To find a two-tone combination, two indicators are so designed that in a colour circle they point to two colours which lie at an angle of 180 degrees – in other words, two colours which lie opposite each other.
b) The three indicators for a three-tone combination lie at an angle of 120 degrees to each other.
c) The four indicators for a four-tone combination lie at an angle of 90 degrees to each other.

If you draw indicators in three circles, these circles can be cut out and laid on the colour circle to indicate tone combinations. By turning the circles you will discover that in the twenty-four-colour circle there are twelve two-tone combinations, eight three-tone combinations and six four-tone combinations which can be used.

The colours in the colour-tone combinations determined by the indicators cannot be used indiscriminately or without restriction. We have already seen that colours laid down in combination can dominate or be subordinate to each other. This must be taken into account when using colours from a colour-tone combination.

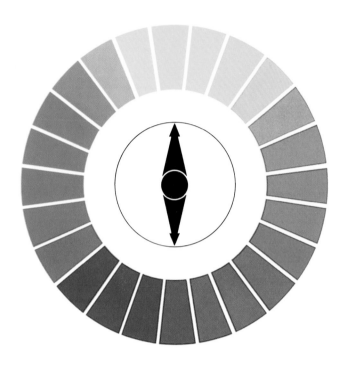

THE TWO-TONE COMBINATION

A two-tone colour combination is composed of harmonious colours and always contains one warm and one cool colour.
 Example:
The indicators show the two-tone combination of yellow and violet. These two colours are complementary (they lie opposite each other), and so present a strong contrast in colour. The warm yellow dominates the violet, which recedes. If you wish to bring these colours into harmony, you can:
a) limit the area of yellow and increase the area of violet.
b) add a little red to both the yellow and the violet, which gives them a colour in common. The colours come closer together and therefore harmonise better.

 If you turn the indicators four colour positions further, you find the two-tone combination of orange and blue. Of these, orange is the warm colour and blue is the cool. When used together the warm colour dominates the cool colour. Consider, for example, a bedroom with a blue carpet and blue curtains. This room is restful and cool due to the influence of the blue.

 If we now introduce an orange blanket, wardrobe and curtains into the room, this colour will become dominant and the room appear unrestful, in spite of the fact the blue and orange harmonise with each other. We can, however, introduce a few touches of orange – a bedspread or a cushion, for example. The blue room, although restful and cool, is also a little dull. The cheerful touches of orange brighten it up.

 Because of the small amount of orange compared to the large amount of blue, there is balance and therefore harmony.

THE THREE-TONE COMBINATION

A three-tone combination consists of:
a) two warm colours and one cool colour
(for example, warm yellow and red and
cool blue).
b) one warm colour and two cool colours
(for example, warm orange and cool
greenish – yellow and violet).

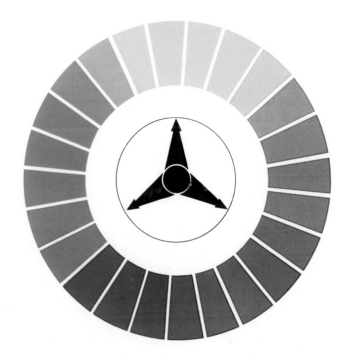

THE FOUR-TONE COMBINATION

A four-tone combination really consists
of a double two-tone combination and
therefore contains two pairs of contrast-
ing colours. A four-tone combination is
thus built up of two warm colours and
two cool colours. The four-tone combi-
nation illustrated here contains yellow
(warm) and violet (cool) and green (cool)
and red (warm). When using a four-tone
combination it is necessary – just as it
was when using the two-tone combina-
tion – to add colour in order to bring the
colours into harmony.

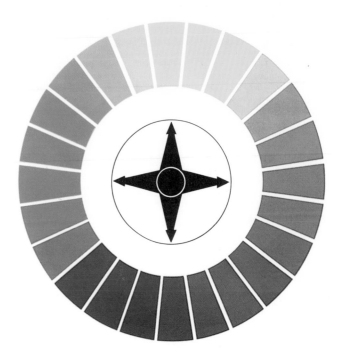

Colours from the two-tone combination of green and red are not harmonious when they are used in equal quantities.

This exercise in composition, in which green and red planes of colour (the two-tone combination) are laid down in the same 'proportion', but not balanced, can scarcely be considered harmonious. The composition gives a restless impression because the colours accentuate each other and attack the eye. Although the colours have been applied with strict regularity, optically speaking this regularity is far from obvious.

It is still possible to construct this composition so that a balance between the colours is created. This is achieved by decreasing the amount of dominant red in relation to green. This creates a harmonious division of the planes of colour, which makes the colour composition more interesting.

Red and green are brought into balance in this composition.

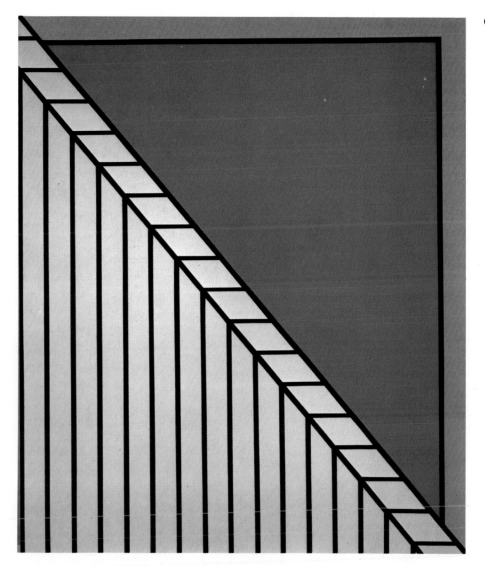

Cocly – 1968
NICOLAS KRUSHENICK

THE APPLICATION OF
COLOUR-TONE COMBINATIONS IN
PAINTINGS

THE APPLICATION OF THE TWO-TONE
COMBINATION WITH LINE In this com-
position Krushenick incorporated shape,
colour and line. The blue and orange
(complementary colours) are so treated
that the small band of orange cannot
dominate the large receding area. Togeth-
er they form a unity. In their turn the
areas of colour restrain the movement
of the lines. In this way, line and colour
create a balance.

THE APPLICATION OF THE THREE-TONE COMBINATION In his work Mondriaan freed himself from all ties with the external world. To achieve this he banished all manifestations of nature and complied only with his own rules. These are expressed in the straight lines and rigid planes in the primary colours red, yellow and blue, filled out with colourless white, grey and black. In this way – using very few materials – he attempted to achieve the highest form of harmony.

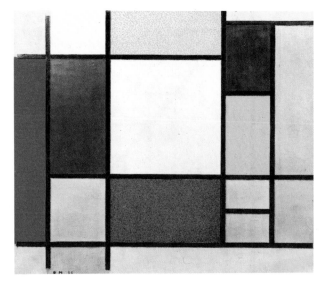

*Composition in Red,
Yellow and Blue* – 1920
PIET MONDRIAAN

THE APPLICATION OF THE THREE-TONE COMBINATION In this painting, Ardon used the same colours as Mondriaan used in his *Composition in Red, Yellow and Blue*. These paintings are completely different in conception, but if you look carefully at the two illustrations, you will discover that they both have a great harmony in common. Mondriaan achieved this by means of the red plane particularly (see what happens when you cover this with your hand).

Ardon achieved harmony by restraining the red area with the black and by drawing attention away from the red by placing the two yellow objects to the left in the red area.

The House of Maggid
– 1954
MORDECHAI ARDON

Composition

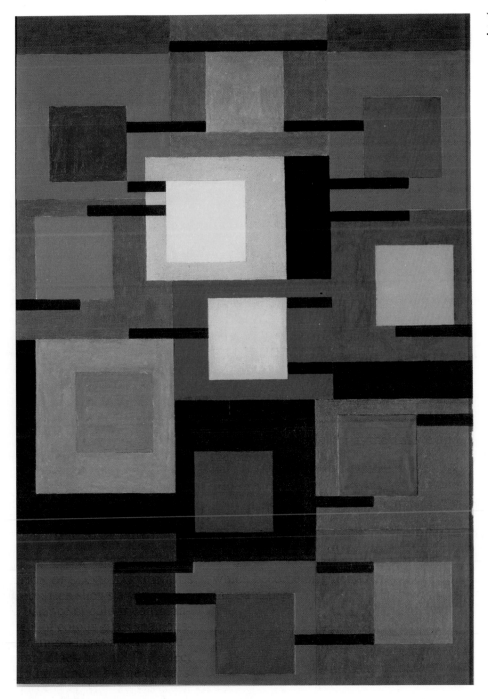

THE APPLICATION OF MANY HARMONIOUS COLOURS Here Itten shows a very sophisticated balance of colour combinations. The effect of colour gives spaciousness to the painting. This is accentuated by the horizontal black beams. The effect of depth is also influenced by the colours which become brighter as they move up the painting.

A FURTHER LOOK AT COMPOSITION

Don Nederhand, Will Goris and Lenie Aardse explain by means of several paintings and drawings how they achieve balance in their work.

Pastel – undated
DON NEDERHAND

Acrylic – undated
DON NEDERHAND

The subject is placed to the left of a flat plane. Balance is created by the perspectival movement of the subject, via the white area, to the darker opening at the right of the picture.

The subject is placed away from the middle in an upright plane. Balance is created by the saturation of the yellow in the background at the top left of the paper.

Because the yellow (from the warm wavelength region) pushes itself forward and thus stands out, a diagonal filling-in from bottom right to top left is created.

Acrylic – undated
DON NEDERHAND

Watercolour – 1985
WILL GORIS

The subject is placed in an upright format to the bottom left. Balance is created by the diagonal movement from the bottom right to the top left.

The nude is placed away from the middle and to the left. The vertical red area in the centre would keep her there, but the touch of blue paint on the right-hand side brings the picture into balance.

Siberian chalk and watercolour – 1985
WILL GORIS

Watercolour – 1986
WILL GORIS

The billiards player is placed along the right-hand edge of the paper. The painting is held in balance by the yellow lamplight and the light area around the ball in the bottom left of the picture.

The nude stands to the right in the fore-ground, supported by the edge of the paper. The red in the top right corner, where her head leaves the edge of the paper, take over this support. The red touches to the left of the model pull the composition into balance.

Mixed technique – undated
LENIE AARDSE

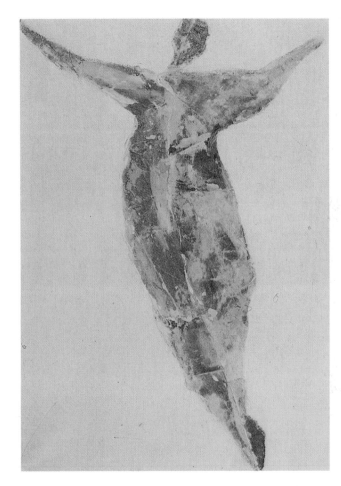

Mixed technique
– undated
LENIE AARDSE

It is as though this elongated figure indicates the length and width of the canvas. The horizontal lines of the planes in the background break up the emptiness and give support to the lines of the arm. Moreover, the large area to the left holds the canvas in balance.

This composition, in all its simplicity, is beautifully in balance with the canvas. The figure covers the whole area and because of its perfect positioning there is no need whatsoever for counterbalance.

PERSPECTIVE

Wall painting in the caves of Lascaux, in France.

There is no perpective in the cave murals. The subjects were placed next to and above each other.

SPACE

The space in which we exist is three-dimensional. In it we can move left and right, up and down, forwards and back-wards and vice versa. Space, therefore, has three dimensions – *width, length* and *depth.*

A piece of paper is flat. It has two di-mensions – *width* and *length.* It has no depth. In principle a drawing or a paint-ing on paper should therefore also be two-dimensional. We only need to con-sider our ancient ancestors, who drew or painted their flat images next to or above each other. Long ago artists felt it necessary to represent space in their work

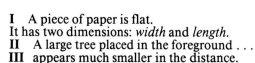

I A piece of paper is flat.
It has two dimensions: *width* and *length.*
II A large tree placed in the foreground . . .
III appears much smaller in the distance.

and discovered that a few artistic devices are sufficient to suggest depth on a flat surface. This effect of depth is one of the fundamental principles of perspective which not only makes it possible to rep-resent space itself, but also to represent the objects within that space.

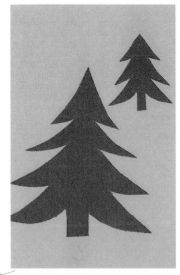

IV The first tree stands in the foreground and the second tree in the background. This creates depth on the flat surface. A third dimension, *depth*, is thus added to the two dimensions of width and length.

V A tree placed at the edge of the paper indeed suggests a great deal of space in the background, but precludes activity in the foreground.

VI A foreground is created by moving the tree further back. This increases the *effect of depth*.

VII The two-dimensional surface can also be broken and depth created by means of a *ground line*. This also creates a third dimension. Here, such a ground line also forms the *horizon*. By placing the ground line low, opportunities for large areas of sky are created. This simple indication could suggest sea and sky.

VIII If the ground line is placed higher, however, emphasis is placed on the sea. The large sea creates a strong effect of depth. The horizon now lies high and far in the distance.

IX The relationship between the sea and sky is in proportion if the ground line lies approximately in the middle. Both now play an equally important role.

X The effect of depth is also different when the large tree is placed on three different backgrounds. The subject lies close. It surrounds us, so to speak.

XI When the large trees are replaced by small ones, this has an influence on the proportion and therefore on the effect of depth. The subject no longer surrounds us because it lies further away.

XII In this cold seascape all the elements are placed apart. They do not touch each other.

XIII Here, two objects are placed one behind the other. This phenomenon is known as overlapping. Overlapping heightens the effect of depth.

XIV The ship is now sailing behind the iceberg. Here, too, the feeling of depth is heightened by the overlapping effect. The sun is sinking below the horizon.

XV This effect of depth can be increased still further by means of a ground line or by placing an object in the foreground. The ice floe in the foreground gives the spectator a greater feeling of involvement: it creates the impression that he is actually on the ice floe. Further overlappings give greater depths. The ship is sailing behind the iceberg and the sun is behind the ship.

The horizon line between the sea and sky is determined by the height of your eye.

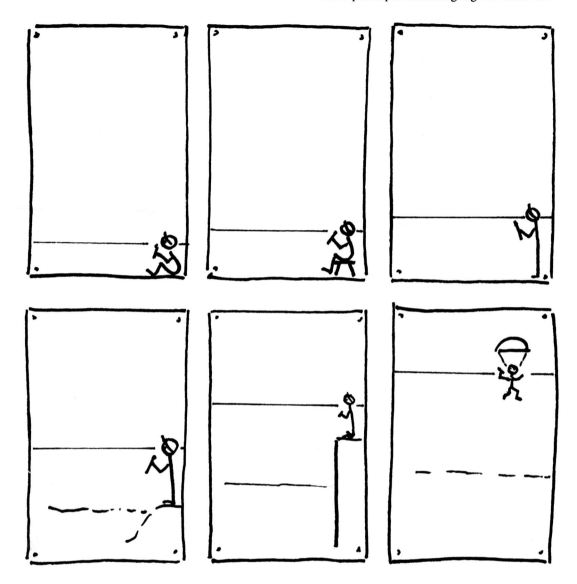

THE HORIZON LINE The horizon line is not a fixed line, but is determined by the limit of your vision.

This horizon line is most clearly discernible when you look out to sea and nothing breaks the imaginary line which separates the sea and the sky. The height of the horizon is not fixed, but is determined by the height of your eye. In other words, if you sit on the ground you see a low horizon because your eye is low. If you stand up, your eye is higher and therefore the horizon line is higher. Objects often break the horizon line. Depending on the height of your eye, objects will lie to a greater or lesser extent above or below the horizon line.

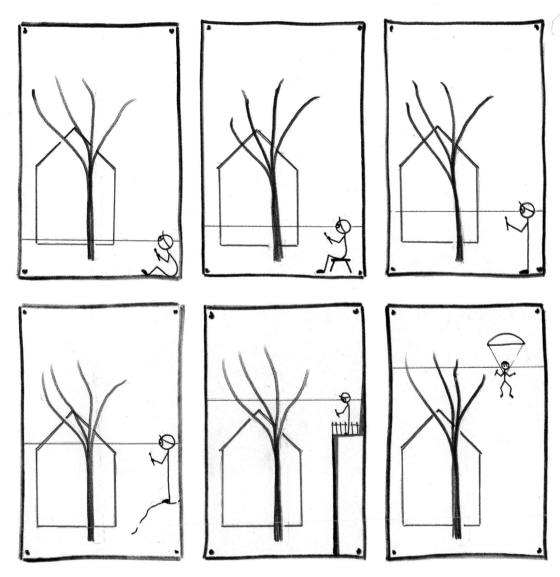

Objects lie above or below the horizon line, depending on the height of your eye.

THE HORIZON LINE IN PAINTINGS

March – 1895
ISAAC ILTICH
LEVITANE

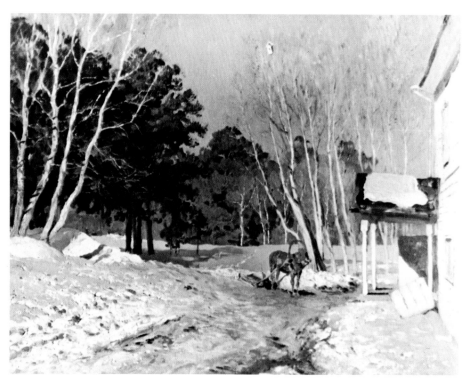

In this winter landscape the horizon line lies just below the middle. This creates a clear foreground and background, both of which play an important part in the painting. The bare birches and the darker conifers behind them form a lovely translucent contrast. This heightens the effect of depth. Although the edge of the wood impedes the view, the painting still has a great impression of space.

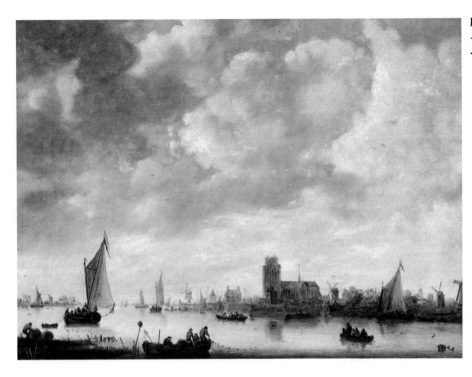

View of Dordrecht
– c.1648
JAN VAN GOYEN

Because of the low position of the horizon line, van Goyen was able to give emphasis to the typically Dutch sky, while at the same time this low standpoint provides a view far across the water. It is remarkable how van Goyen was able to depict such activity on the water with such a small strip of foreground without attracting attention away from the sky above it. The painting has enormous depth.

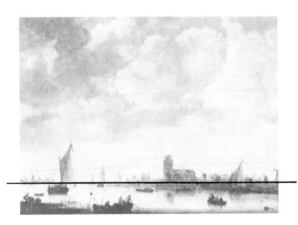

View of Saint-Tropez
– 1904
HENRI MATISSE

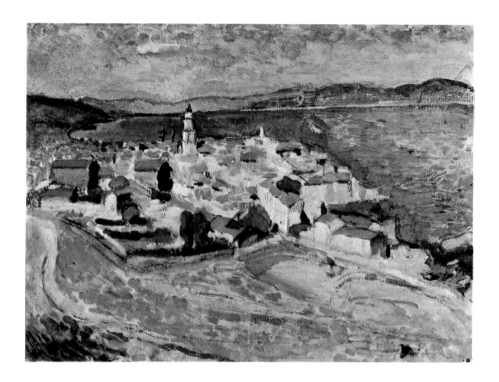

The town is painted from a high standpoint and lies below the horizon line. We are looking across at the roofs. The town lies some distance away. This is achieved by placing a large area of land in the foreground. The water emphasizes the width of the scene. The sky plays a less important role.

*Walchensee With a
Yellow Field* – 1921
LOVIS CORINTH

This village is painted from a very high stand-
point and lies, as it were, at the painter's feet.
The horizon line therefore lies outside the
canvas so that the sky does not appear in the
painting. This type of perspective is known
as 'bird's-eye view perspective'. We are look-
ing down at the roofs of the houses.

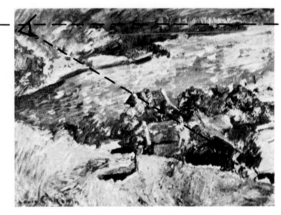

SINGLE POINT PERSPECTIVE

I Space is created by placing a horizontal line on a flat surface. Although the space is empty, it evokes instinctive images and we associate it with land, water or sky.

II We can put a stream in the land by means of two more horizontal lines. From its bank, we now look across the stream and the land until we reach the limit of vision. This is the horizon line and we can see no farther.

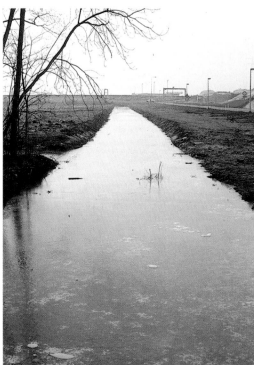

III The further the stream is from us, the narrower it appears to be. We know this is an optical illusion, but we are so accustomed to it that it hardly surprises us.

IV The fact that two parallel lines meet each other at infinity is a fundamental principle in line perspective drawing. This point lies on the horizon line and is known as the vanishing point.

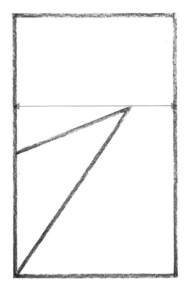

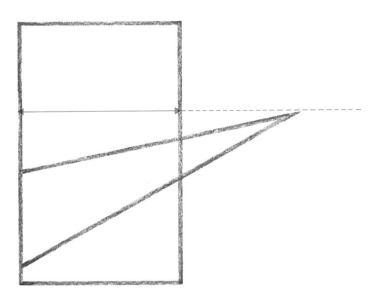

V Because we can stand in various positions in relation to the stream, we can also observe it from various angles. The position of the vanishing point depends on this angle.

VI Because the stream is drawn from a particular angle, the vanishing point lies outside the paper. Both lines meet at that point. To begin you can lay a sheet of paper under your working surface to help you to ascertain the course of the lines. In this way you can still see the vanishing point. After a little practice, you will not need to do this. You will be able to imagine the paths of lines which pass out of the working surface.

SINGLE POINT PERSPECTIVE IN PAINTINGS

A similarity can be seen between this painting and sketch V. It is painted from the right-hand bank. Although the artist has applied perspective, he saw no reason to follow nature faithfully. He has striven to translate the landscape rather than set it down visually. His work is clearly Expressionist.

Landscape in Dangast – 1910
KARL
SCHMIDT-ROTTLUFF

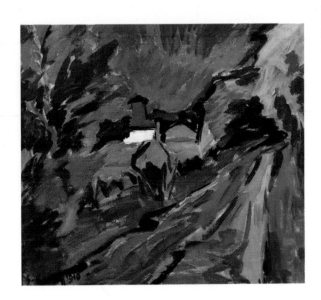

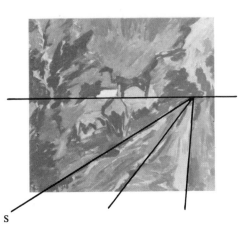

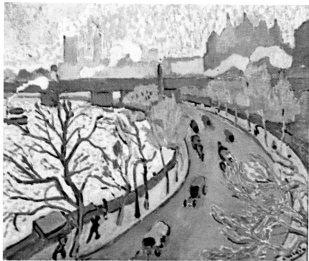

Westminster Bridge
– 1907
ANDRÉ DERAIN

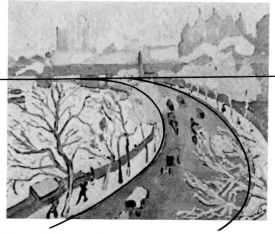

Curved lines, such as those here in the road, also move closer together as they approach the horizon. The subject is painted from a higher standpoint, and we therefore look down on the trees and cars. The top of the tree in the foreground strengthens the effect of depth. Through his highly personal use of colour, Derain achieves dynamic activity in the foreground in contrast to the static city in the background.

VII In roads which rise sharply, the two parallel lines do not meet. The view is impeded by the rising road.

VIII When the highest point is reached, however, the road again becomes visible as far as the horizon line where the parallel lines meet. From a higher standpoint the road appears to recede. This creates a concertina-like effect. You can observe this effect more clearly by drawing two lines touching the horizon (as in ill. IV) on a heavy sheet of paper. Fold the paper like a concertina and hold it at eye level. You now see how the receding effect is created.

VANISHING LINES

IX A pole appears to be much smaller if it is positioned further back in the canvas. To find the correct proportion two lines are drawn, one from the top on the pole to the horizon line and one from the bottom of the pole to the point at which the first line touches the horizon line. These lines are known as vanishing lines and their purpose is to establish the perspectival reduction of depicted objects. The size of the objects which lie further away is determined by the distance between the two vanishing lines. Objects in the foreground which lie below the horizon line remain under the horizon line when they are positioned further away. One determines the height of the poles which stand in the immediate environment, but not in the row between the vanishing lines, as shown here.

X Objects in the foreground which project above the horizon line, also project above it if they must be drawn further away. Vanishing lines which determine the height of the object then lie above the horizon line.

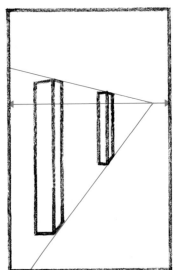

VANISHING LINES IN PAINTINGS

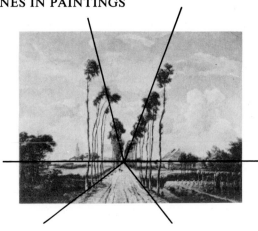

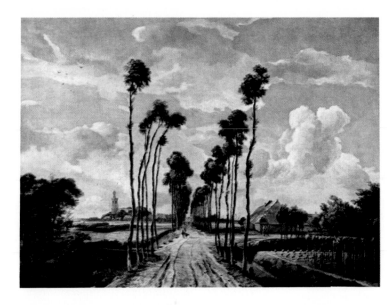

The long road is bordered by tall, thin trees. We get a good impression of how they diminish optically as they approach the vanishing point on the horizon. Because the horizon line is positioned low, the trees rise far above it and therefore form part of the area of sky. Hobbema applied single point perspective in this painting. Because the road is placed in the centre of the painting, the viewer has the impression that he is actually on the road and walking towards the man with the dog, plodding along the gritty surface and trying to avoid the deep ruts of the cart tracks. The painting is therefore strongly inviting. Rigidity is avoided by placing the trees at slightly irregular distances from each other and by allowing some of them to bend. This also creates movement in the picture.

*The Avenue, Middle-
harnis*
– 1689
MEINDERT HOBBEMA

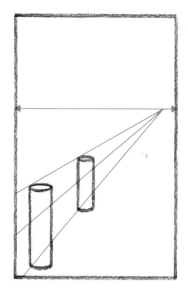
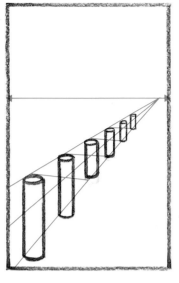

POSITIONING OBJECTS AT EQUAL DISTANCES

XI If objects are to be situated at equal distances, the perspectival reduction necessary to indicate them can be determined. To do this, place a pole in the foreground and from it draw vanishing lines to the horizon line. Draw a third vanishing line from the centre of the pole, as shown here. Draw a second pole, and with it establish the distance between the two poles.

XII The position in which the third pole must be drawn on the lowest vanishing line is determined by drawing a diagonal line from the top of the first pole through the centre of the second. The position of the fourth pole is determined by repeating this procedure and drawing a diagonal line from the top of the second pole through the middle of the third.

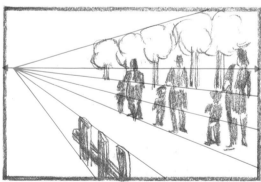

XIII The ability to determine distance accurately is useful for depicting objects in which exactitude is necessary. Always bear in mind, however, that this can produce great rigidity in a drawing or painting. An irregular row of poles or trees makes a picture more light-hearted and gives it more movement. See illustration XII for this.

XIV Several of the preceding examples are combined in this sketch. Everything in the foreground lies in a particular relation to the horizon. This relationship is not affected if the same objects are positioned further away.

Boston Common at Dusk – 1885-86
CHILDE HASSAN

The row of poles lies below the horizon line and the trees project above it. With regard to the horizon line, all the adults reach it, while the children remain far below it. The row of poles is painted much more rigidly than the row of trees, which gives a good counterbalance.

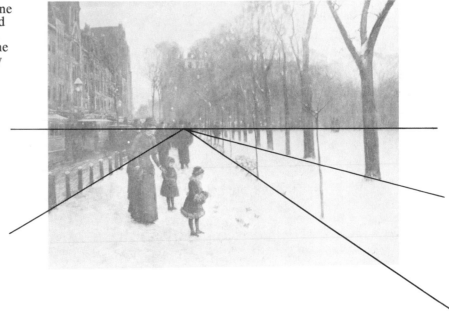

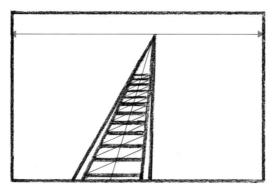

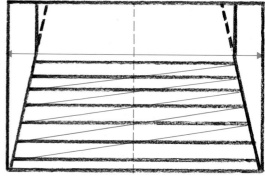

XV The perspectival reduction of the railway lines is determined in the same way as the reduction of the row of poles in illustration XII. The diagonals, however, are now drawn from the left-hand side of the first railway sleeper through the centre point of the second. This line ends at the point where the third sleeper must be positioned.

XVI Now that you are familiar with this system, drawing this planked floor will not present any problem. The vanishing point lies outside the working surface. The diagonal lines start at the perspectival line of the left-hand wall.

VANISHING POINTS IN PAINTINGS

Legend of the Profanation of the Host
c. 1467
PAOLO UCCELLO

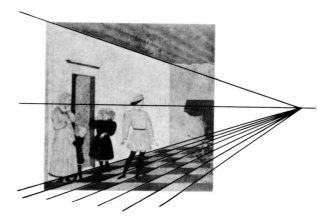

Here the vanishing point lies outside the panel to the right and therefore creates the impression that the room lies to the left of the viewer. Because of this the viewer is drawn directly into the activity, although he remains an observer of the scene.

It can be seen from this and the following illustration that the position from which you choose to make a piece of work determines the way in which it will appear to the viewer.

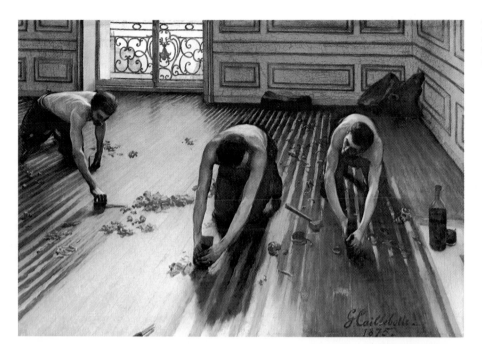

The Parquet Layers
– 1875
GUSTAVE
CAILLEBOTTE

In this painting, the horizon line lies just above the centre of the canvas. The viewer is therefore looking down at the workmen.

The horizon line can be found by extending the lines in the parquet. The horizon line lies at the point where these lines meet. Notice the right-hand wall which follows the same direction as the lines in the parquet. The rhythm of these lines is accentuated by the movement of the workmen's arms.

Because the vanishing point is roughly in the middle of the picture, the viewer is looking directly into the room. He is therefore directly drawn into the activity.

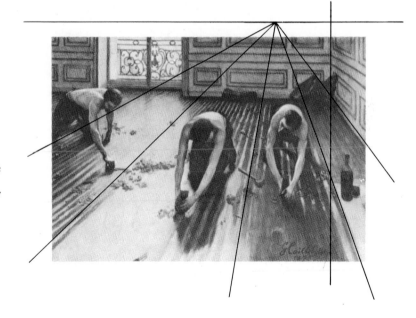

LINE, PERSPECTIVE AND VOLUME

We have discussed the depiction of level roads, railway lines and streams and the positioning of people, poles and trees in space; but we can also place in perspective objects which have greater volume (length, width and height). If you take up a position directly in front of the subject you wish to draw, then you can provisionally limit yourself to the application of single point perspective.

To elucidate:

I If you place a box directly in front of you at eye level, the imaginary horizon line runs exactly through the middle of it. You can only see the width and height of the box. If you should now draw the box, it would consist only of a rectangular shape. The volume of the box is not visible. If you position the box a little lower, you can partly see into it.

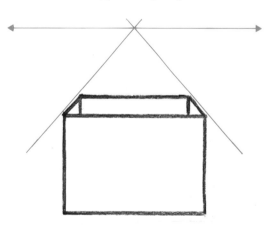

The box now lies below eye level. When this image is reproduced, the box is also placed below the horizon line. You again draw the rectangular visible surface. Because you can look into the box, you can see a part of the three other sides. Now mark a vanishing point exactly in the middle of the box on the horizon line and draw vanishing lines from

this point to the upper corners of the surface of the box. These vanishing lines indicate the direction of the perspectival reduction. The box now has three dimensions.

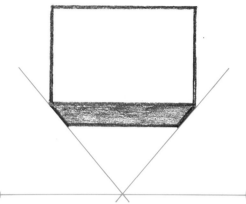

When you position the subject higher, it lies above eye level. You then draw the box above the horizon line. You now see the underside of the box. The vanishing lines are again drawn to the vanishing point, so indicating the perspectival reduction of the sides.

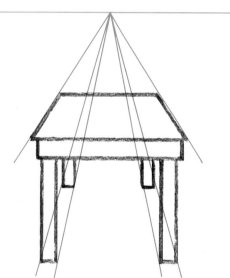

II All manner of objects can be depicted in this way by making use of single point perspective, providing that the vanishing point is positioned exactly in the middle, above or below the object.

TWO POINT PERSPECTIVE

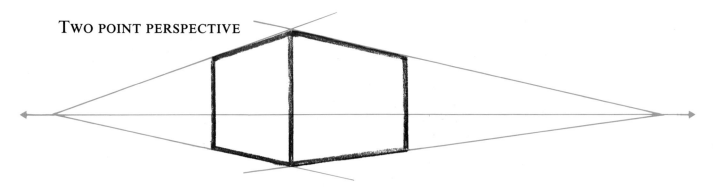

III If you wish to depict objects so that not only the front, upper or under surface is visible, but also one of the sides, then you must make use of two point perspective. If you study illustration III, you will see that the two planes of the block each have their own vanishing point. This makes it possible to depict objects from different standpoints.

Just as in the positioning of objects when single point perspective is applied, how you view the block is determined by its position with respect to the horizon line. Moreover, the positions of the vanishing points vary. In one instance they must be positioned closer together than in another. In order to obtain good proportion, it is often necessary to place the vanishing points outside the working surface. In the beginning, you can again place a sheet of paper under your working surface to enable you to determine the distance more easily.

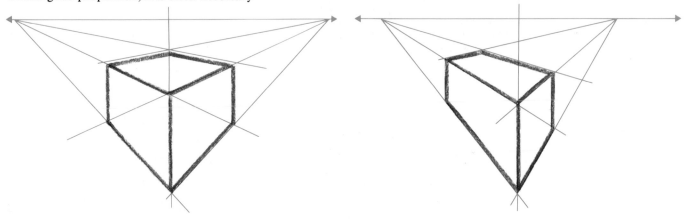

IV The block in illustration IV is lying with one corner pointing towards you. Try to imagine how the table, shown in illustration II and drawn using single point perspective, would appear if you drew it using two point perspective. Imagine also that this drawing is a block of houses. In both cases you are looking down on the object, in the first at the table top and in the second on the roof of the block of houses.

V The closer together the vanishing points are placed, the more acute the perspectival distortion will be. If this drawing represented a block of houses, you would be looking down at it from a great height. (This is again, therefore, an example of bird's-eye view perspective.) In this case the vanishing points are placed differently with respect to the middle point, because of which the lengths of the sides differ.

VI A shape can be depicted in different ways by using the forms of perspective applied here.

Never forget, however, that the foregoing working drawings are purely technical and are only intended to illustrate the perspectival reduction of the subjects. When these lines are necessary in a particular piece of work, they must be drawn very lightly to indicate the correct direction. You execute the original design with a pen or brush in your own 'handwriting'. To see this, compare these illustrations with the working drawings.

Jan Krediet – 1982
NICO H. PEETERS

VII Now that you have learnt to draw various block shapes in perspective, it will no longer be difficult for you to recognize these shapes in drawings and paintings. If you examine Nico Peeter's painting of an articulated lorry, it will be immediately clear to you that it is composed of two blocks in receding perspective. The first determines the perspective of the cabin and the second the perspectival reduction of the trailer. Because the elements of the lorry still form an entity, all these elements follow the same line of perspective. This not only applies to, for example, the wheels, but also to the red, yellow and blue planes of colour on the lorry. The name 'Jan Krediet' is also in the same perspective.

'Black Riders' Tram
STUDENTS OF THE
RIETVELD ACADEMY,
AMSTERDAM

VIII It is a different matter when an articulated vehicle must be depicted on a bend. The tram in illustration VIII gives an example of this situation (a). The outlines of the tram have been drawn in order to make the distortion in perspective clear (b).

If the horizon line is placed in the sketch, you will see that the tram indeed has perspectival reduction, but that the line is broken by each succeeding carriage.

Now lay strips of paper along the top and bottom edges of the first carriage and determine the vanishing point. Do this for each part of the tram. You will find that each carriage *has its own vanishing point*. This comes about because the carriages are all lying in different directions due to the curvature of the tram rails.

This is known as *multiple point perspective*.

This implies that objects placed in different directions with respect to the horizon line each have their own vanishing point on the horizon line.

To learn to handle these perspectival effects, use strips of paper in the same way as above, to practise determining the reduction of planes and lines in photographs in magazines and books.

Watching television is also a useful exercise. The framework provided by the screen plays a useful role in this because it helps you to determine the direction in which lines are travelling. Because the images on the screen are moving, you have the opportunity of continually seeing objects from different angles. In order to concentrate fully on this, it is advisable to turn the sound down.

THE POSITIONING OF OBJECTS

Objects can be positioned on a piece of
paper or a canvas in different ways.

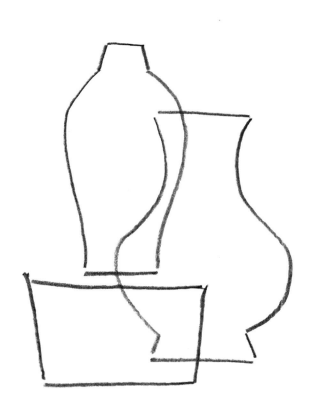

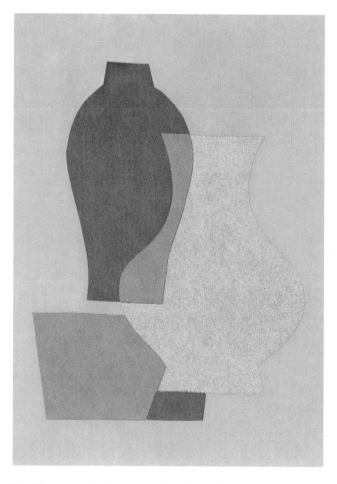

I You can, for example, make a light-
hearted line drawing in which the combina-
tion of *line* and *shape*, which run together,
is the most important factor in image and
composition. A visually faithful image is not
important and the object itself only serves
as the source of inspiration.

II You can do the same thing by dealing
decoratively with the object. This creates a
combination of *colour and shape* which is
the essence of this drawing. Here, too, a faith-
ful representation is of secondary importance.

Both these examples concern a free transla-
tion of the subject. Whether the positioning
of the subject in the ground plane would be
theoretically possible is irrelevant.

III If, however, you wish to make a drawing or painting which gives a visual representation of the arranged objects you are using, you must position them in your working surface beforehand in order to determine whether they can actually be positioned there. Every object has its own ground plane and also a particular volume.

In order to make illustration III, the ground planes of the objects are first determined. Then account must be taken of the shape of the kettle, which is wider near the top and thus takes up more space than its ground plane indicates. The largest circumference of the kettle is therefore the dimension it occupies in the ground plane. This is important in this arrangement because the ground plane of the cylinder which stands behind the kettle may not, and cannot, encroach on that of the kettle, but must remain outside it. Only then will the positioning of the object work.

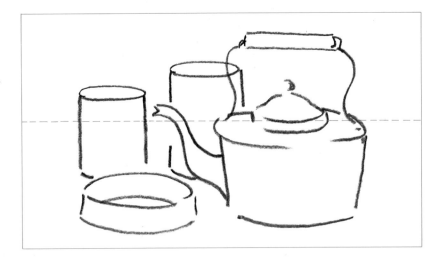

IV Another method of determining the position objects occupy in a plane is illustrated here. By drawing a plane division you can determine precisely where the different objects are positioned and if what you had in mind actually works in practice.

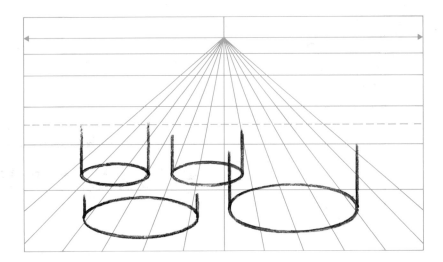

FROM THE CIRCLE TO THE ELLIPSE

Elliptical shapes are used a great deal in drawing and painting – plates, jugs, pots, vases, bowls, tins, tubes, wheels, car tyres, and so forth.

Many people find drawing ellipses difficult, but again by learning to apply a few 'tricks of the trade', you will be able to handle this problem.

Take a plate from the cupboard and sit down at the table. The plate represents the circle you drew in the square. If you hold the plate in front of you as if it were a road sign – on its side – then you see its perfect circular shape. If you hold the plate horizontally at eye level, then you see it only as a thin line. If you put the plate on the table in front of you and look directly down at it, you again see its perfect circular shape.

Now lay the plate on the table about three feet away from you. If you observe the plate carefully you will see that the circle has been transformed into an ellipse. It is often this optical transformation that creates difficulty when creating a design. One recognizes the circular form but does not always consciously experience the optical transformation. If you wish to depict the plate as you now see it, you must take into account the fact that it lies below eye level. The plate is therefore drawn below the horizon line.

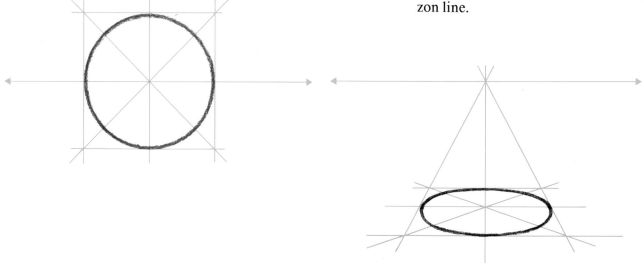

I The first step is to draw a circle in a perfect square with the assistance of two straight and two diagonal axes. This is the basic shape on which the whole system is based. This drawing can be interpreted in two ways. The square can be seen as a horizontal plane or as a vertical plane. In the first case you look directly at it, and in the second you look down on it from above.

II To depict the plate on the table in front of you, you first draw a square in perspectival reduction below the horizon line. Use single point perspective for this. Straight and diagonal axes are added to the plane which has been created. The plane is no longer square, as it is in illustration I, but is much narrower due to the perspectival reduction.

Draw an ellipse in this plane in the same way that you drew the circle in the square.

If you wish to work out roughly where you must position the plate below the horizon line, then experiment with it again. By continuously holding the plate a little lower, you will at first see a narrow ellipse which becomes steadily more circular as you lower the plate. Eventually you will again be looking directly down at it and will see the plate as a circle. After this experiment you will be able to work out roughly where you must position the plate with respect to the horizon line. This exercise might appear unnecessary, but you will derive a great deal of benefit from experiencing optical transformation in practice.

In order to learn how an ellipse is created and how it can be drawn at various angles, it is advisable to carry out a few exercises. At first you will find the corresponding construction lines are absolutely necessary, but later, perhaps with a few construction lines as support, you will be able to draw ellipses directly on your paper or canvas.

CYLINDERS

III If you hold up an empty tin so that the horizon line lies exactly through the middle of it, then you will see the tin as nothing more than a rectangle. At most the areas of shadow and the fall of light are what betray its round form.

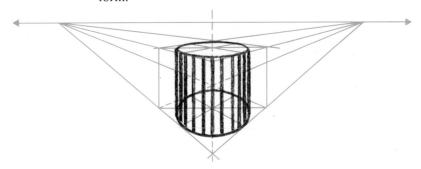

IV Place the tin about three feet away from you. Just as in the plate, the upper edge is transformed into an ellipse. Because the tin is cylindrical it has a top and a bottom, and therefore there are two ellipses. You can experience how these two ellipses lie in relation to each other if you first draw a cube using one or two point perspective. Then draw the straight and diagonal axes in the upper and lower planes of the cube and draw the ellipses. These ellipses differ in shape. The upper ellipse is fairly flat because it lies close to the horizon line. The lower ellipse is much more circular. It lies further away from the horizon line so that you observe it from a more vertical position; the shape is therefore more circular.

A cylinder is created by joining the ellipses together with two vertical lines.

If the drawing is rotated through 180 degrees, the tin stands not *below*, but *above* the horizon line.

The lower ellipse is now the narrowest and the upper the most circular. Again this is the result of the relationship between ellipse and horizon line.

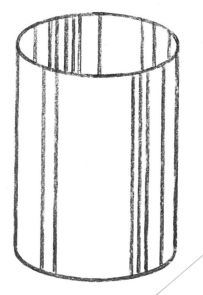

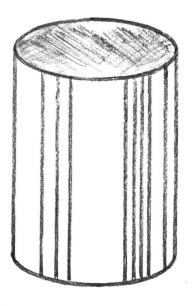

V By applying tone, in this case by adding line structures both to the inside and outside, the cylinder becomes round and hollow, thus creating a true representation of the tin.

VI If we change the direction of the structures in the upper ellipse, it appears that the tin is upside down, or that it is unopened. In this way structures add to the clarity of the design.

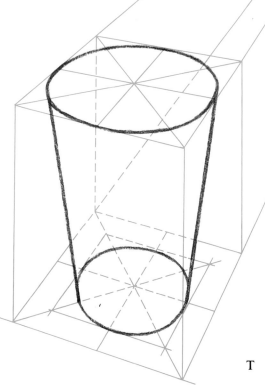

VII Other shapes are created by changing the size of the ellipses with respect to each other. This can also be done by changing the vertical lines of the shape. The cylindrical shape is the basic form for all kinds of pots and pans, vases and so forth.

Watercolour
– undated
Rob Komala

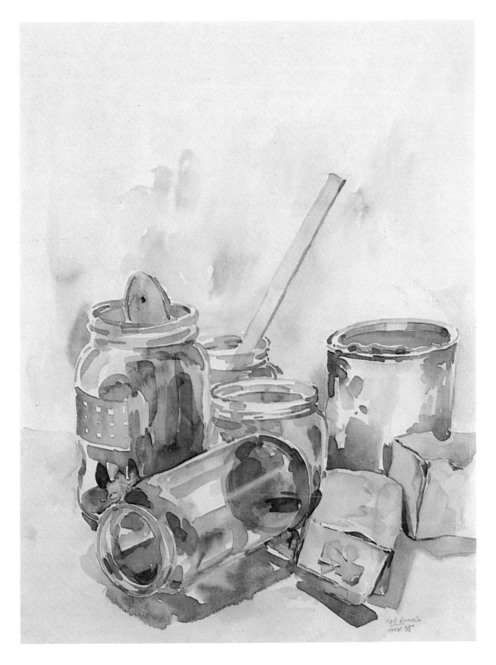

Many ellipses have been used in this composition of various painters' materials. Notice the double ellipse visible through the glass of the pot which has fallen over.

WHEELS

Unless you are drawing a frontal view,
ellipses are also employed in the drawing
of the wheels of cars, trains, barrows,
children's prams, carts and so forth.
Now, however, you are confronted with
ellipses which are mostly placed in the
vertical.

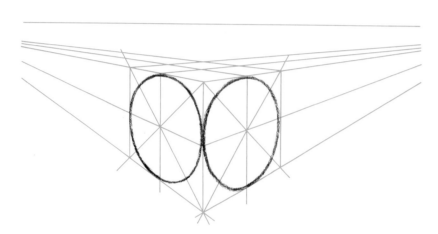

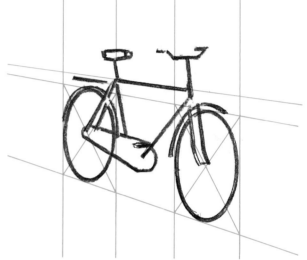

I A cube is again used to help represent the
perspectival reduction of the wheels accurate-
ly. Vertical ellipses are drawn within the ver-
tical faces of the cube.
 Now suppose that this ellipse is the wheel of
a wheelbarrow – then the other lines of the
vehicle are laid down in the same direction
as the vanishing lines of the wheel. In this
way perspectival proportion of the wheelbar-
row is created.

II If the vehicle to be depicted has more
wheels, such as is the case with a bicycle, then
the second wheel is drawn behind the first,
but between the vanishing lines of the fore-
most wheel. The other parts of the bicycle
are drawn in the same direction as the van-
ishing lines.
 The position of the vanishing point on the
horizon line again determines the angle at
which the bicycle is drawn. In illustration II
the bicycle is travelling towards you and the
front wheel is therefore larger than the back
wheel.

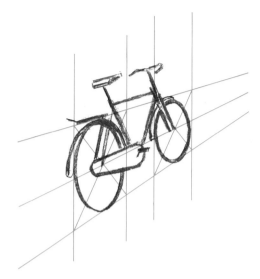

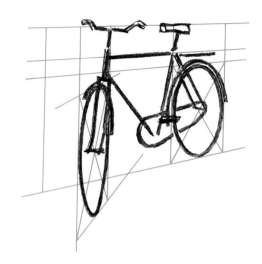

III In this illustration, the bicycle is going the other way and therefore the back wheel is larger than the front.

IV The front wheel of a bicycle can be at a different angle than the back wheel. In such a situation, that wheel has its own vanishing point on the horizon line. Compare this with the illustration of the tram on page 101.

V Car tyres, cart wheels, the driving wheel of a steamroller, the caterpillar tracks of a tractor, and so on, have a particular thickness or width.

This width is created in the perspectival reduction by drawing two ellipses one behind the other between the vanishing lines intended for this purpose. The vanishing lines are determined by the foremost ellipse of the wheel. An axle has its own vanishing lines and these run to the same vanishing point as those of the wheel itself.

If the front wheels of a vehicle are at a different angle to that of the vehicle itself, then the same situation as that in illustration IV occurs. The front tyres then have their own vanishing point on the horizon line.

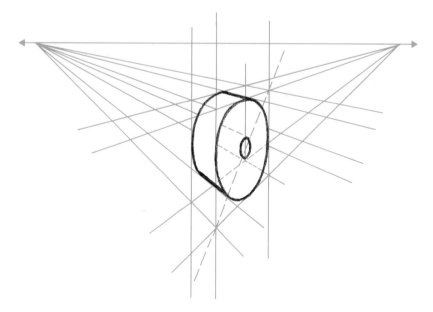

ARCHES

Many buildings have arched windows, doors and gateways. You draw them by using the same principle that you applied in the perspectival drawing of circles to create ellipses.

I a) A circle is drawn and used as a basic form for the front view of an arch.
b) The vertical lines of the windows, doors or gateways are extended from out of half of the circle.
c) For positioning arches in side walls, the circle shapes are first drawn in perspective. The required arches can then be derived from these.

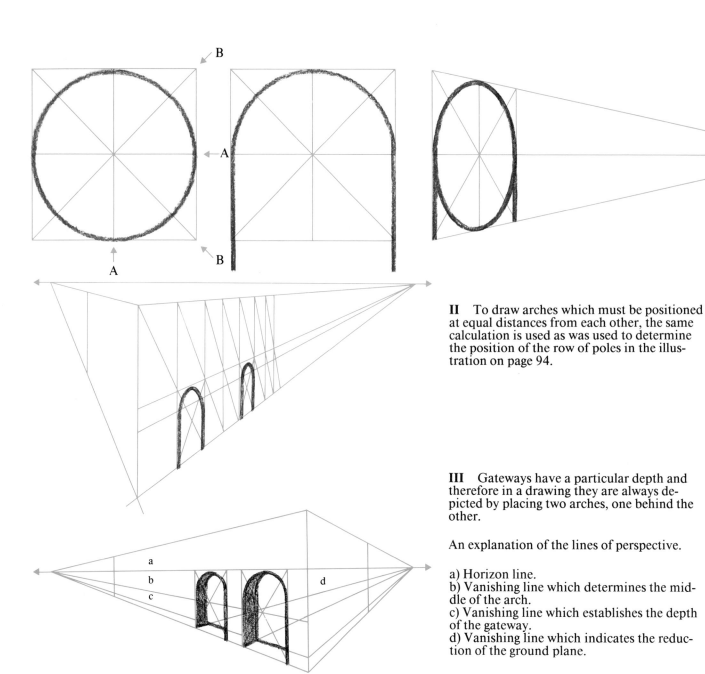

II To draw arches which must be positioned at equal distances from each other, the same calculation is used as was used to determine the position of the row of poles in the illustration on page 94.

III Gateways have a particular depth and therefore in a drawing they are always depicted by placing two arches, one behind the other.

An explanation of the lines of perspective.

a) Horizon line.
b) Vanishing line which determines the middle of the arch.
c) Vanishing line which establishes the depth of the gateway.
d) Vanishing line which indicates the reduction of the ground plane.

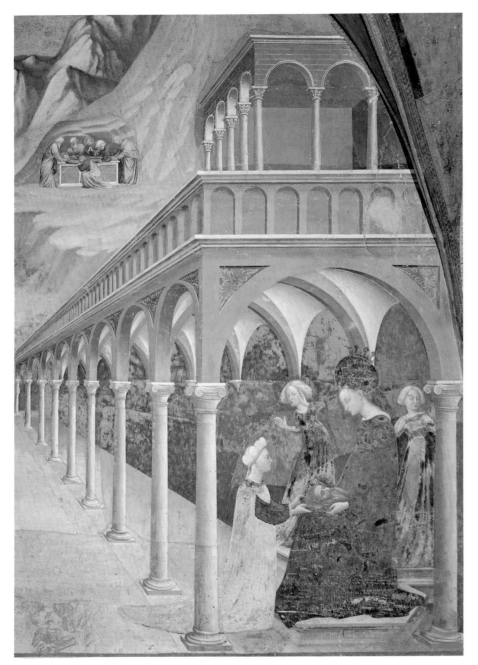

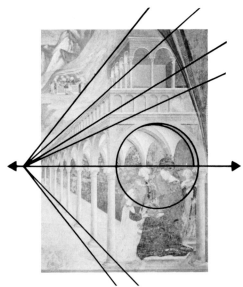

Herod's Banquet
– c. 1413 (detail)
MASOLINO DE
PANICALE

APPLYING ARCHES IN PAINTINGS

This fresco gives a clear example of how arches are placed, both in pure circle form and as ellipses. The circle forms are easily recognizable in the frontal view.

Notice the perspectival reduction of the building. All the vanishing lines run to the same vanishing point on the horizon line.

The arches assume the same direction of perspective.

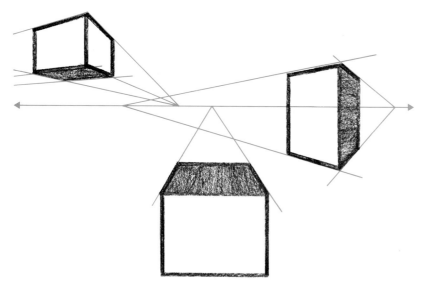

Each object has its own vanishing point with respect to the horizon line.

MULTIPLE POINT PERSPECTIVE

Now that the principle of single and two point perspective is clear, we will discuss the application of multiple point perspective. Before we begin, however, let us briefly summarize the foregoing aspects of perspective:

During your work, you have already discovered that the vanishing points of an object can be in different places, depending on your viewpoint with respect to the object. That object can be positioned with the aid of single or two point perspective, in which it is possible for a vanishing point to fall outside the working surface.

If you add more objects to your drawing, then each object has its own depth of perspective and therefore its own vanishing points. This is clearly shown in the differently drawn building blocks in the illustration above.

There are also objects which because of their shape have several vanishing points. These are objects which are composed of several shapes and these will be explained here. If there are more than two vanishing points, we speak of 'multiple point perspective'.

By making use of a series of toy building blocks, from which objects that can be studied from different viewpoints have been built, the changes these have undergone are made clearly visible. The photographs are arranged to show shapes in increasing degrees of difficulty ranging from the simplest shape to more complex composite shapes.

A working drawing is provided with some of these examples, in others you must make the working drawing, or determine the perspectival reduction of the building blocks, yourself.

The building block house in this photograph is built up from a rectangle and a triangle. Because we are looking directly at the house and because the horizon line lies through the centre of the object, the planes are not transformed and only the front elevation of the house is visible.

This photograph of a gateway is also taken from directly in front. The gate is built up from a square (the two gateposts) and a horizontal triangle from which the arch is cut. Here, too, only the front elevation of the gateway is visible, because the horizon line runs through the centre of the object.

If you take a viewpoint with respect to the gateway from which its depth can be seen, the perspective is transformed. This gateway, therefore, has a perspectival reduction in which the vanishing lines, which indicate the depth, meet at a vanishing point on the horizon line. The lines of the facade, in contrast, have their own vanishing point which lies outside the working surface (two point perspective).

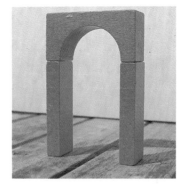
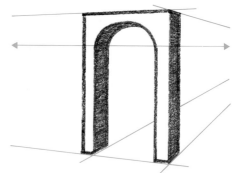

This building block house also has a front and a side view; and therefore here, too, the depth can be seen. From the working drawing it emerges that the house lies below the horizon line. The highest point of the roof lies practically on the horizon line.

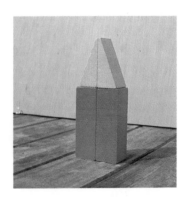
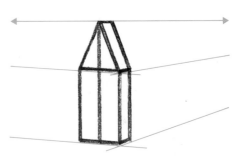

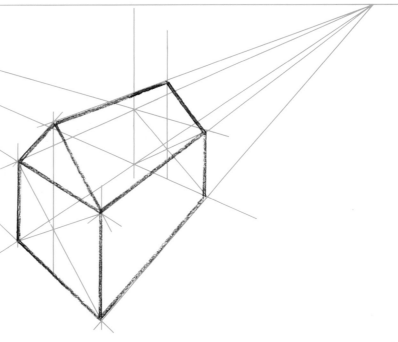

The working drawing of this house shows that it is drawn far below the horizon line. You are looking above the roof and therefore the house has considerable depth. The height of the gable is determined by drawing a perpendicular line through the midpoint of the facade. Two diagonal lines to form the shape of the gable are drawn from this perpendicular. You are looking directly at the right-hand side of the roof. The diagonal line of the *rear elevation* is drawn to the same point as that of the *front elevation*. This house has been given its shape by means of the application of *multiple point perspective*.

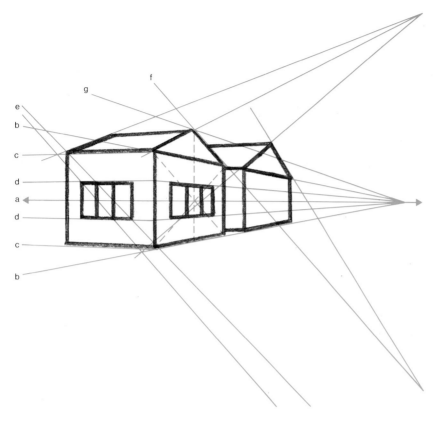

Two houses stand next to each other in this working drawing. At first sight, the many construction lines are deterring, but if you study the explanation below, everything will fall into place. It is a recapitulation of that which has been dealt with earlier.

a) Horizon line.
b) Vanishing lines which indicate the direc-

c) Vanishing lines which indicate the direc-

d) Vanishing lines which determine the per-

e) Diagonals which determine the perspectival reduction of the second window
f) Vanishing lines which indicate the direction

g) A vanishing line which establishes the perspectival reduction of the top of the roof.
 The roof of the second house is therefore higher than that of the first house.

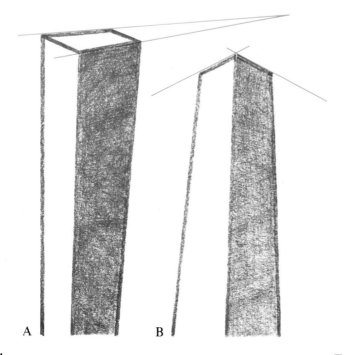

If you flew over a built-up area, then the roofs of the houses would be closest to you. The more directly above the roofs your view is, the greater is the reduction in perspective.
 A) The parallel lines approach at increasingly narrow angles. They have their vanishing points deep under the surface of the earth.
 B) You observe the same distortion when you stand beside a building and look up the wall. The parallel lines also appear to approach each other at steeper angles, but in contrast to example A, their vanishing point is high in the sky.

114

Perspective

Imagine these two toy building blocks are skyscrapers. A working drawing clearly illustrates the afore mentioned distortion. This time, determine for yourself the function of the vanishing lines, following the example given on the previous page, below.

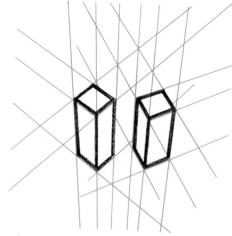

The photographs to the right represent two groups of houses. With the aid of a few strips of paper, try in these photographs:
a) to establish the horizon lines
b) to determine the angle of sight at which the photographs were taken.

If you place several buildings next to each other, as is the case in the photographs mentioned above, then you must determine whether the ground plane of each building has its own position on the surface on which it is drawn. The ground planes must not overlap each other.

In order to be able to visualize this in three dimensions, you can construct a plane division with vanishing lines radiating from two vanishing points, as in the illustration to the right. On this lay the contours of a random building, work out the ground planes of the buildings you wish to add and set their ground planes down. In the same way you can also determine the ground planes of shapes placed on top of each other. This helps you to find out what is technically feasible.

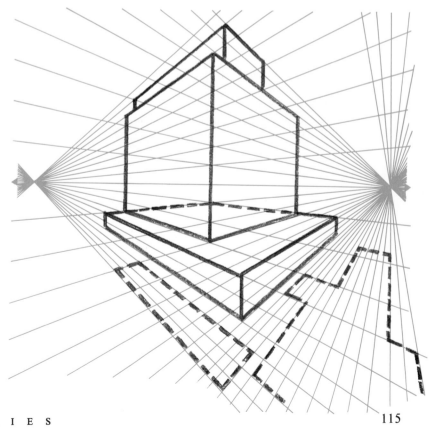

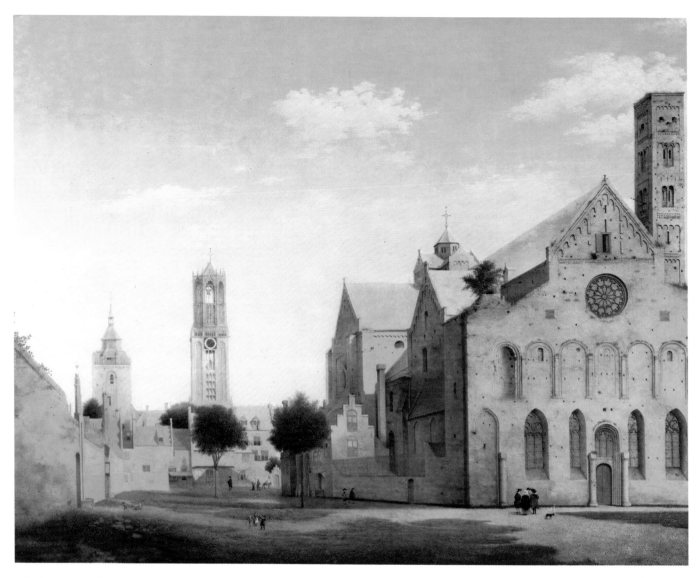

The Square and Maria Church in Utrecht – 1663
PIETER JANSZ SAENREDAM

This painting by Saenredam contains such a group of buildings. Determine the ground planes of some of them by laying a sheet of tracing paper over the painting. Also establish the horizon line.

From a technical point of view, many paintings contain inaccuracies in the application of perspectival transformations. This can be due to negligence or inexperience. There is a greater number of paintings, however, where conscious (from a visual view point) distortions have been introduced in order to break the sterility of the work. Many artists have concerned themselves with what the optical distortions of objects brought about. Albrecht Dürer (1471 – 1528) who concerned himself with the pure, natural reproduction of those things which surround us, was already using all kinds of aids to establish perspectival reduction. Among other things, he used a framework divided into squares which he placed in front of his subject. By means of a working surface subdivided into squares, objects were positioned on the paper or canvas area by area.

These are fine aids for practising in order to gain insight into the question of perspectival reduction of objects. It would be going too far, however, indeed even inadvisable, to apply this type of working method to your pieces of work.